IMAGES
of America

COLUMBUS
1860–1910

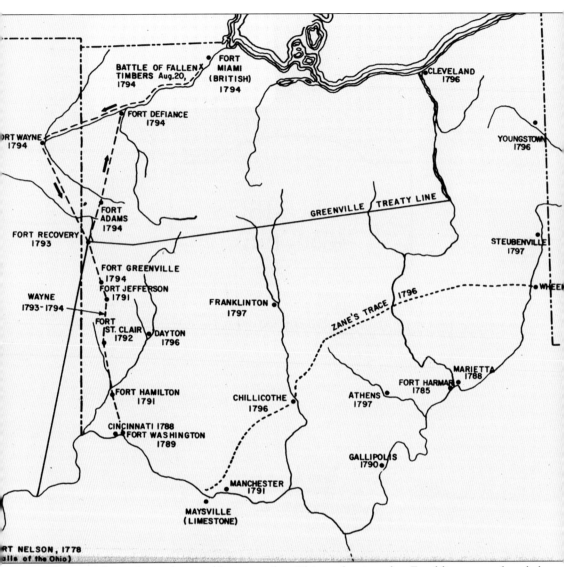

This map shows the settlements that existed in Ohio at the time that Franklinton was founded on the west bank of the Scioto River in what is now part of Columbus. Franklinton was the first settlement in the center of Ohio and the only settlement north of the Chillicothe except for Cleveland, Youngstown, and Steubenville. The only settlements in Ohio that were more than a year old when the first settlers arrived at Franklinton were those along the Ohio River. The forts shown in the western part of the state were established by Gen. Anthony "Mad Anthony" Wayne during his campaign to subdue the American Indians that would threaten settlers. In the peace treaty that was signed on August 3, 1795, the American Indians surrendered all claims to land south of the Greenville Treaty Line. This opened the opportunity for settlement of the interior of Ohio and for the birth of Franklinton, and later Columbus.

IMAGES
of America

COLUMBUS
1860–1910

Richard E. Barrett

ARCADIA
PUBLISHING

Published by Arcadia Publishing
Charleston, South Carolina

Printed in the United States of America

Library of Congress Catalog Card Number: 2005928575

For all general information contact Arcadia Publishing at:
Telephone 843-853-2070
Fax 843-853-0044
E-mail sales@arcadiapublishing.com
For customer service and orders:
Toll-Free 1-888-313-2665

Visit us on the Internet at www.arcadiapublishing.com

CONTENTS

ACKNOWLEDGMENTS

The author would like to acknowledge the assistance provided in preparing this volume by the staff of the Biography, History, and Travel Department of the Columbus Metropolitan Library in helping to identify their resources, in answering research questions, and providing access to their image collection. Special thanks are due Sam Roshon of the library for his interest and encouragement in preparing the book. Thanks also are due Bruce Warner and Chris Bourne for permitting the author access to their image collections.

Special thanks are due the author's wife, Margie, who has supported his interest in local history for over three decades.

INTRODUCTION

Columbus is a unique city in that it was selected to be the future state capital while no town, or even a village, existed at the time the decision was made. There was a settlement on the west bank of the Scioto River; it was called Franklinton. In 1812, while the Ohio legislature (then meeting at Chillicothe) was working to identify a site for a permanent state capital, a number of proposals were submitted. Those proposing their towns for the capital included Worthington, Dublin, and Delaware. Franklinton was briefly considered but was quickly eliminated because of the repeated floods in this low lying area. Each proposal included land and contributions to fund state buildings at the site.

At the last minute, four gentlemen who had acquired rights to the land on the high east bank of the Scioto River, opposite Franklinton, submitted a proposal. They proposed to give the state two 10-acre sites, one for the state capital building(s) and one for a penitentiary. They also offered $50,000 toward buildings on those sites. Less than a month after this proposal was submitted it was accepted, but not without charges of chicanery.

In February 1812, when the site on the east bank of the Scioto River was chosen to be the site of the state capital and the name Columbus was chosen, there were at most a few scattered cabins on the site. In June 1812, the selling of lots in the new town was commenced and Columbus was underway.

At first, Franklinton exceeded Columbus in importance, especially during the War of 1812 when Franklinton was an outpost on the western frontier. However, Franklinton grew at a slow rate and Columbus soon overtook it in size and importance. In 1816, the state legislature began meeting in Columbus, and in 1824 the county seat was moved from Franklinton to Columbus, reflecting the development of the new capital. In 1870, Columbus annexed Franklinton, although the Franklinton area neighborhood maintains its identity.

Columbus: 1860–1910 presents views of Columbus following the availability of practical cameras. As there was limited use of cameras at the time of the Civil War, some of the earliest views are represented by drawings. Later views are more often represented by photographs. It is unfortunate that many original photographs do not appear to have been preserved, thus some of the views presented have had to be extracted from publications from many years ago. The quality of some views is not what the author would like, but they represent the best that could be obtained.

The material presented in this book is divided into sections representing important periods in local history—the Civil War years, the postwar period, and so on In addition, two chapters are devoted to special topics, specifically the celebrations of 1888 and Olentangy Park.

Much of the material presented in this book is from the author's personal archive, collected over a 33 year period. Other views were obtained from the Columbus Metropolitan Library's Biography, History, and Travel Department which has assembled a collection of over 8,500 views of the Columbus area. Fellow historians Bruce Warner and Chris Bourne assisted by offering their personal collection of views for the authors use.

The author is a well known local historian having authored five previous books, authored and narrated 12 half-hour television presentations, and authors a column, "Postcard from Columbus," that was once carried in the *Columbus Dispatch Sunday Magazine* and now appears in the *Senior Times*. In addition, he regularly speaks on a variety of Columbus area history topics. An active member of the Columbus and Clintonville Historic Societies, in 2004 he received the Columbus Historical Society's first Heroes of History Award.

One

CIVIL WAR YEARS
(1861–1865)

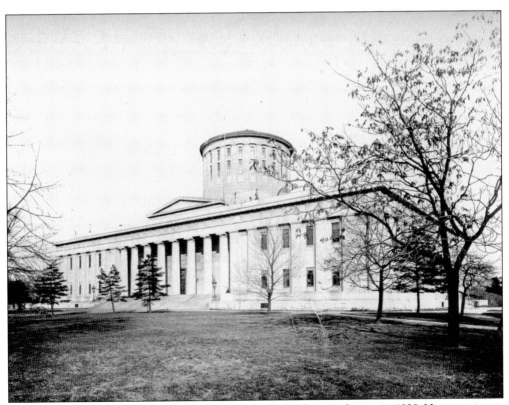

The construction of the new Ohio State House in Columbus was begun in 1839. However, it was not completed until 1861, at the beginning of the Civil War. Continuing debate over whether Columbus should be the permanent state capital and over funding slowed construction. The Ohio State House remains the centerpiece of downtown Columbus and was recently restored to simulate its original décor.

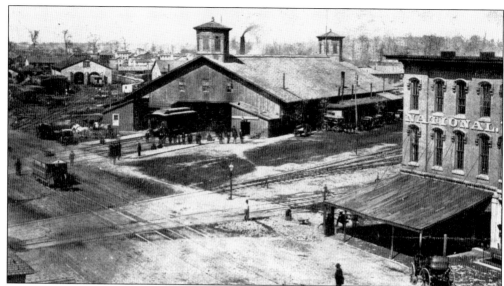

The first railroad reached Columbus in 1850 and this first railroad station was placed in service at that time. By the Civil War, Columbus was a hub of railroad lines reaching out in all directions. Additionally, Columbus was sufficiently close to Virginia (which included West Virginia at the beginning of the war) and Kentucky (a border state) that it could be a supply point for Union troops. Yet Columbus was sufficiently far north to not be threatened by Confederate troops.

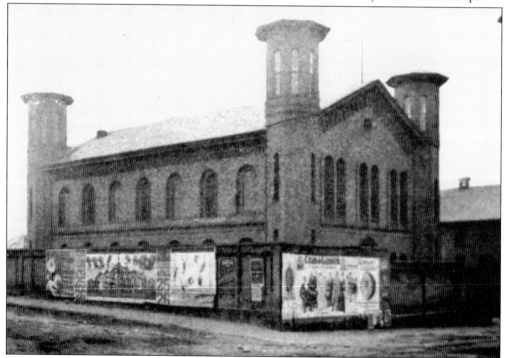

Construction of the Ohio State Arsenal began in 1860 and was completed in 1861. It served as an armory for the Ohio National Guard until 1975. As Ohio furnished more troops in the Civil War on a per capita basis than any other state, the arsenal was an important Civil War facility. Since 1978, this facility has housed Columbus's Cultural Arts Center.

Before and during the Civil War the Underground Railroad passed escaped slaves from one person to another until they reached safety, frequently in Canada before the war or in Union territory after the start of the war. Columbus is believed to have had at least 10 homes and businesses that served as stops (or safe houses) on the Underground Railroad. The Kelton House at 586 East Town Street was one of these, documented by oral histories passed down through family members. When constructed in 1852 by Fernando and Sophia Kelton, the Kelton House was the east most residence on East Town Street and was surrounded by pastures. Runaway slaves may have been hidden in the barn, the 300-barrel cistern, or the servant's quarters. Today, the house is a museum maintained by the Junior League of Columbus.

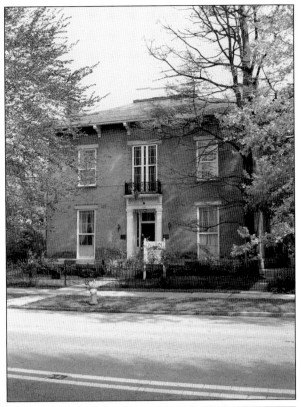

Another local stop on the Underground Railroad was the Clinton Chapel, a Methodist Episcopal Church on North High Street. Currently the chapel (with additions) houses the Southwick–Good and Fortkamp Funeral Chapel shown here. The original chapel is on the right in this view.

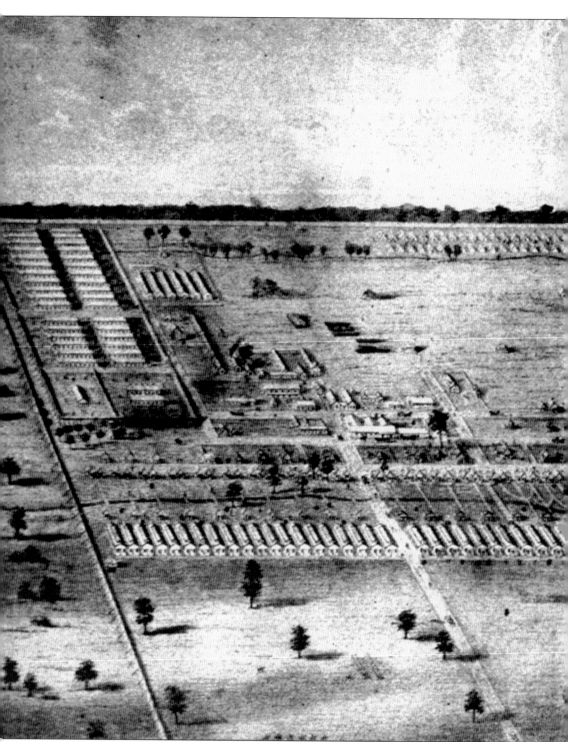

In 1861, a Union recruitment and training facility was established west of Columbus. Camp Chase extended from Broad Street to Sullivant Avenue and from Hague Avenue to Binns Boulevard. Shortly after the camp opened it began receiving Confederate POWs. At its peak, the Camp

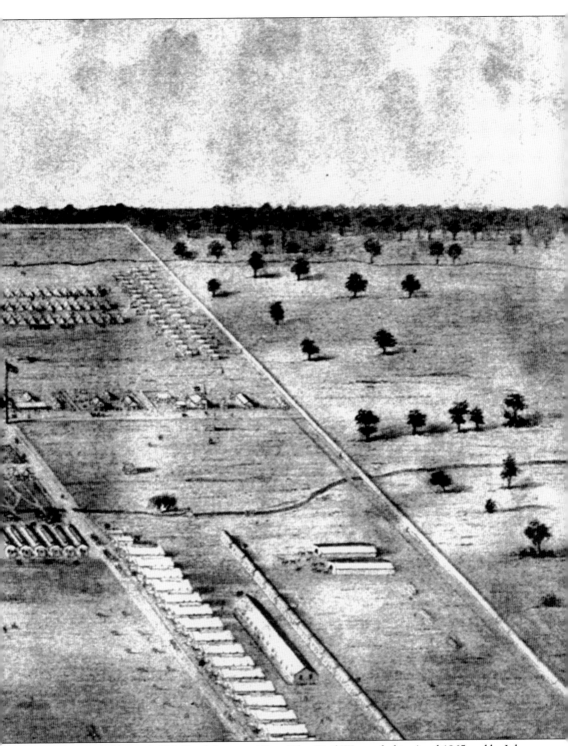

Chase prison held over 8,000 Confederate soldiers. The Civil War ended in April 1865 and by July, the prison was empty. This map of Camp Chase is looking south from Broad Street.

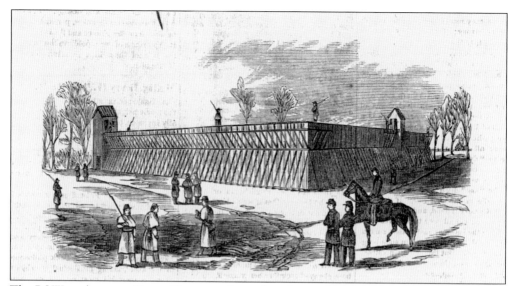

The POW enclosure at Camp Chase was located in the southeast corner of the facility; in the upper left of the previous view. A drawing of the Camp Chase POW area that appeared in the *Saturday Evening Post* of March 1862 described the POW enclosure as being constructed of a 16-foot-high wall of two-inch planks, well braced, and with guard houses. The article mentioned that the 300 prisoners (at that time) were allowed to carve various devices out of pine with their jackknives and that these items were sold in the camp so the prisoners could afford luxuries.

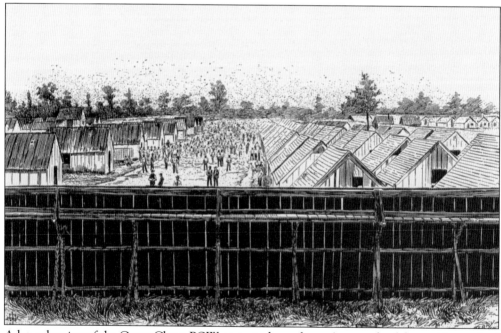

A later drawing of the Camp Chase POW camp is shown here. As a result of the rapid growth of the POW population, many shanties had to be constructed to house the prisoners.

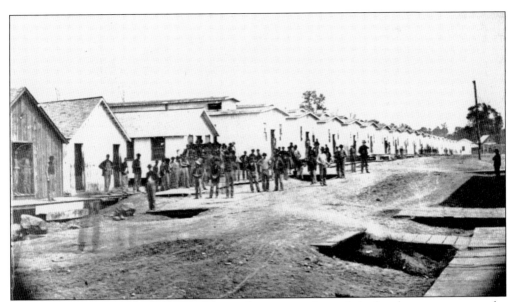

A major street in Camp Chase is seen here, along it were located the headquarters, a store, the post office, and barracks.

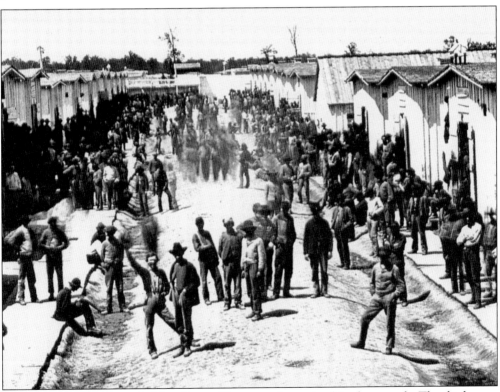

Confederate POWs being held at Camp Chase are shown in this photograph. The ditches on each side of the road served to carry away waste. Consequently, sanitary conditions at the camp were less than desirable and disease was common. However, it should be remembered that sanitary conditions at that time were not much better in the rest of Columbus, or other towns.

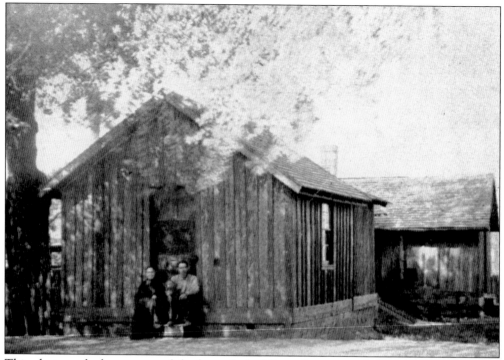

This photograph shows some of the barracks buildings that were salvaged from Camp Chase after it was abandoned. Some of the buildings were hauled away for use as residences or sheds. Individual buildings are known to have been hauled at least eight miles.

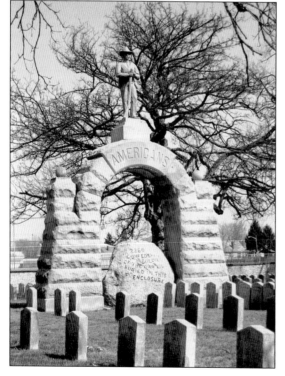

In 1902, this memorial arch was erected in the Camp Chase cemetery by private citizens of Columbus to commemorate the 2,260 Confederate prisoners who died at Camp Chase from battle injuries or disease. Each year on the first Sunday of June, a memorial service is held to honor the deceased Confederate Americans.

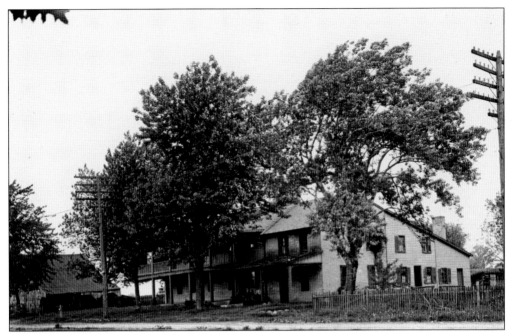

The Four Mile House was an inn built to serve travelers on the National Road. The name was derived from the fact that it was located four miles west of downtown Columbus. Today it would be located on the north side of Broad Street, one or two blocks west of Hague Avenue. The Four Mile House was a favorite spot for Union officers stationed at Camp Chase during the Civil War. It was destroyed by fire in 1913.

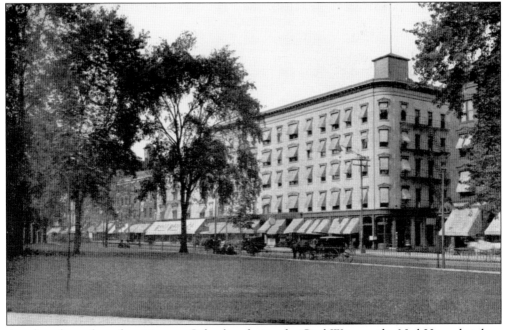

Another place of rest for visitors to Columbus during the Civil War was the Neil House hotel on South High Street (where the Huntington Center now stands). The hotel shown here is the second Neil House on that spot; the first burned in 1860 and this larger hotel was completed in 1862.

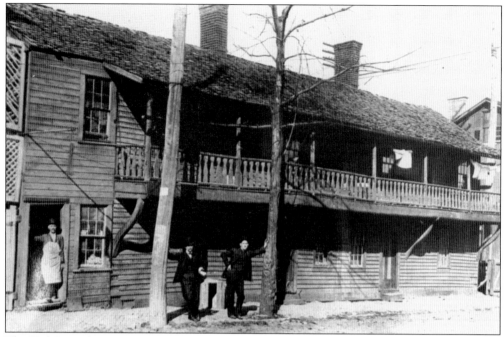

The Tod Barracks was a Civil War barracks located just north of the railroad station at 14 East Popular Street. Besides barracks, the nine-acre facility included two mess halls, a guardhouse, a sutler's store and a small hospital. The Tod Barracks, named for Governor Tod, was opened on December 23, 1863, and closed in July 1865. The last remnant of the facility, the barracks building shown here, was demolished in March 1911.

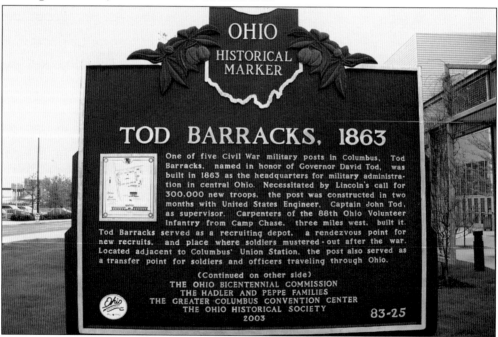

A historical marker located just north of the Greater Columbus Convention Center reminds viewers of the Tod Barracks.

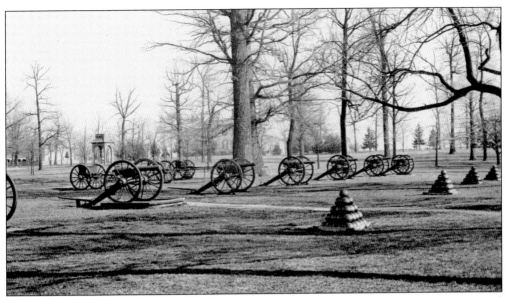

The Columbus Arsenal was established in 1863 on the northeast corner of Buckingham and Cleveland Avenues. In 1875, the name was changed to the Columbus Barracks and in 1922 it became Ft. Hayes in honor of Rutherford B. Hayes. This 1889 photograph shows an array of Civil War cannon at the Columbus Barracks.

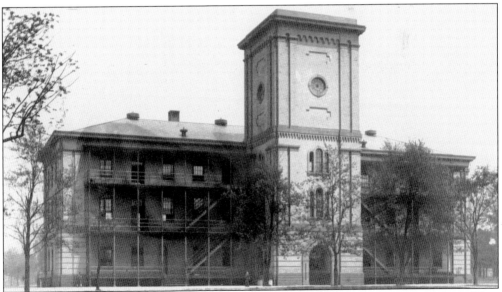

The barracks building shown here was erected at the Columbus Arsenal in 1864 and has frequently been referred to as the shot tower, although it was never used as such. The error occurred because some persons thought that molten lead was dropped from the top of the tower to form lead balls as it fell through the tower.

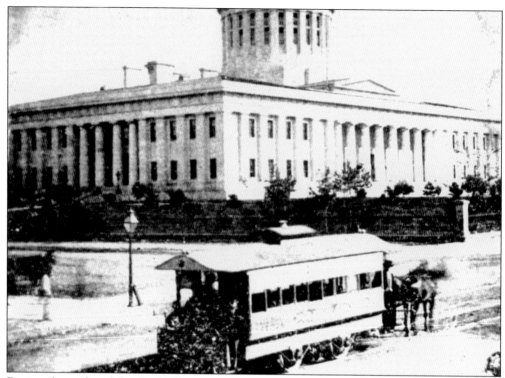

During the midst of the Civil War, in June 1863, Columbus received its first streetcar service. The cars were drawn by one or two horses or mules. The streetcar line initially went from Union Station to the Franklin County Court House; today that would be from Nationwide Boulevard to Livingston Avenue. The fare was 5¢. Within a year the streetcars were running from University (now Goodale) Street to Stewart's Grove (Schiller Park).

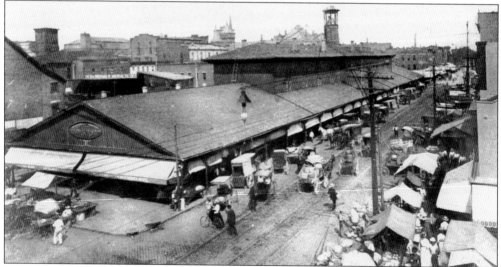

The seat of local government during the Civil War was the second floor of the city-owned market house. The mayor's office, city council chambers, the marshal's office, and the jail were all located there. Built in 1850–1851, the Central Market stood until razed as part of the Market-Mohawk Urban Renewal in the 1960s.

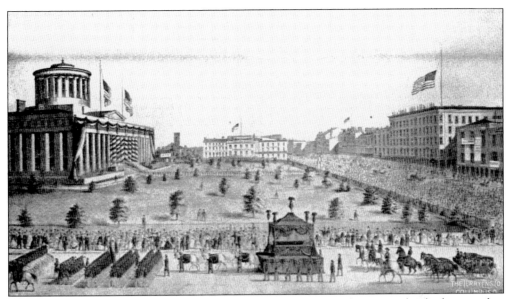

On the morning of April 29, 1865, the funeral train bearing Abraham Lincoln's body arrived in Columbus. The funeral procession shown in this drawing brought the body to the rotunda of the state capital building where it was viewed by an estimated 50,000 persons. In the evening, the funeral procession returned the body to Union Station where it continued its journey to Springfield, Illinois.

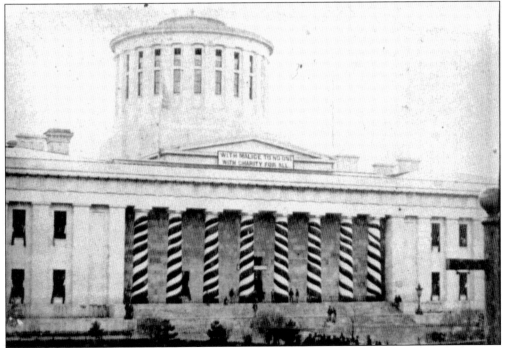

The columns of the Ohio State House were wrapped in black and the rotunda was draped in black for Lincoln's funeral. A sign at the west entrance to the capital grounds read "Ohio Mourns." A sign above the cornice at the front of the state house read "With malice to no one, with charity to all." A sign over the entrance to the statehouse read, "God moves in mysterious ways."

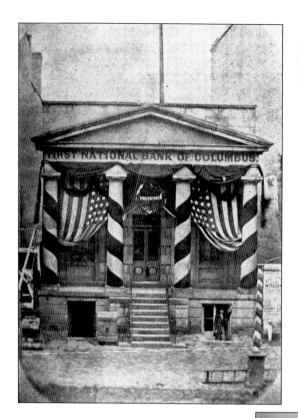

The First National Bank of Columbus, on 106 South High Street, was one of many Columbus buildings draped in black for Lincoln's funeral.

A bust of Lincoln and a monument to the Union victory at the Battle of Vicksburg are included in the Lincoln-Vicksburg Memorial on display in the rotunda of the state house. It was dedicated in 1870 and was one of the earliest Civil War memorials.

Two

THE POSTWAR PERIOD
(1866–1879)

In 1867, Columbus purchased 24 acres of land in what was known as Stewart's Grove for use as a city park, and it was originally called City Park. In 1891, the German population of Columbus donated a statue of the German poet, Freidrich Schiller, to the city for erection in City Park. The park came to be identified by the statue and in 1905 it was renamed Schiller Park. Anti-German feelings during World War I resulted in the park being renamed Washington Park in 1918, but it was renamed Schiller Park in 1930.

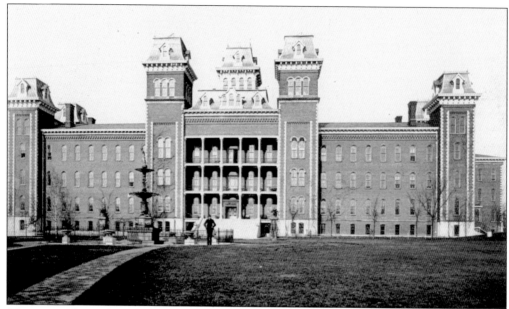

This new Ohio School for the Deaf was opened in 1868 on the same 450 East Town Street location as a previous, smaller facility. The new facility had space for 350 pupils and permitted adding instruction in the printing, book binding, carpentry, and tailoring trades. In 1953, the deaf school was moved to a new facility at 500 Morse Road. A fire destroyed the unoccupied former deaf school in 1981 and the remains were razed.

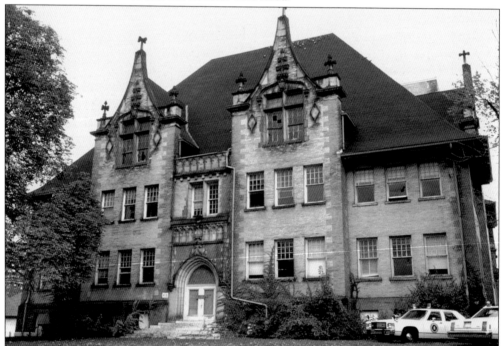

Ground breaking ceremonies for an additional building for the Ohio School for the Deaf were held in September, 1898, and the facility opened November 1, 1899. The new building was located southwest of the main building. This building remains in use as a commercial building.

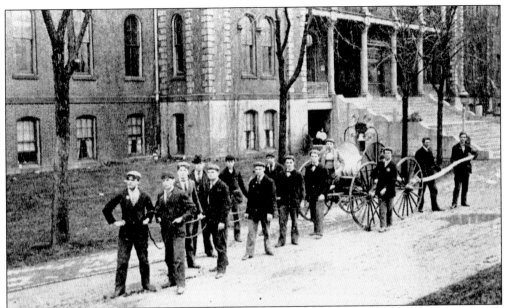

Among the activities of the Ohio School for the Deaf was a student fire brigade, shown in this 1898 photograph.

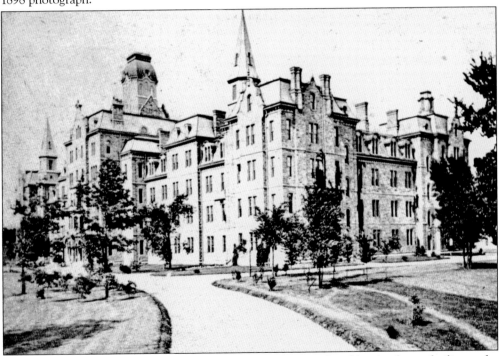

In 1874, the original Ohio State School for the Blind was replaced by this larger facility at the same site on the northeast corner of Parsons Avenue and Main Street. The new facility was designed to accommodate 300 pupils. After the School for the Blind moved to a new facility on North High Street in 1953, this building was occupied for a time by the Ohio Highway Patrol. After setting empty for many years, the building was recently renovated and now houses the Columbus Department of Health.

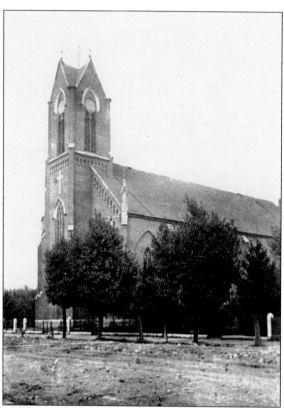

St. Mary's Roman Catholic Church was dedicated in 1868. It is located at 684 South Third Street, in German Village. It was the third Roman Catholic congregation organized in Columbus, following Holy Cross and St. Patrick's, and was built when the Catholic population living in what is now German Village wanted a church closer to their residences. This 1891 photograph shows the church without the tall steeple that was added in 1893.

Trinity Episcopal Church, on the southeast corner of Broad and Third Streets, is an institution in Columbus. This church, which has been located on this site since 1869, continues to provide services for its congregation, serves downtown workers through noontime prayer and communion services, and conducts a homeless ministry.

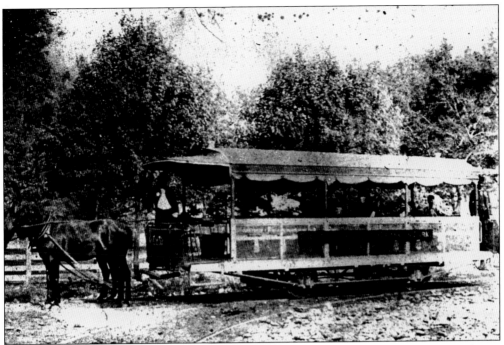

In 1870, the East Park Place Street Railroad Company was authorized to operate a horse drawn streetcar line that ran from the court house to the Ohio State Fairgrounds via High and Long Streets. At this time, the fairgrounds was located in what is now Franklin Park.

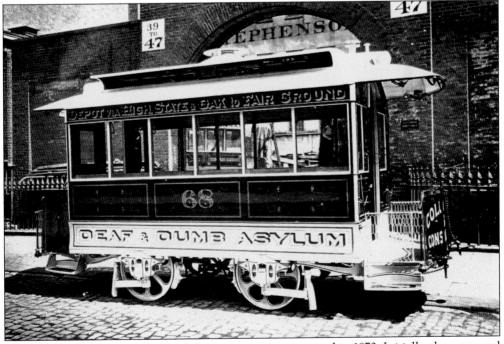

The State and Oak Street Railroad Company was incorporated in 1872. Initially, they operated a horse drawn streetcar that ran between the Union Station and Grant Avenue via State and Oak Streets. In 1882, their service was extended to the fairgrounds, or later, Franklin Park.

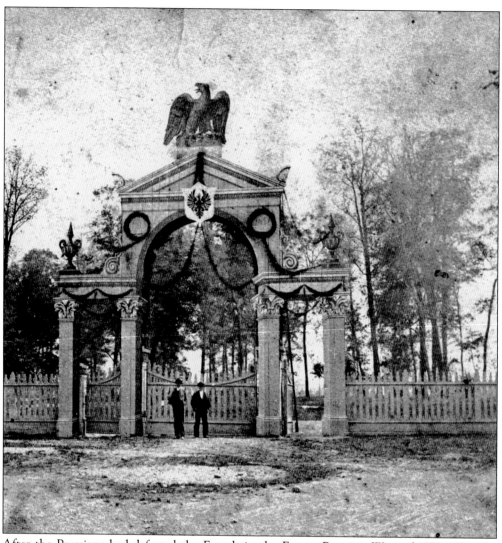

After the Prussians had defeated the French in the Franco-Prussian Wars of 1870–1871, the central Ohio Germans celebrated the peace at Columbus's City (now Schiller) Park on May 1, 1871. Following a parade to the park, 5,000 gathered near the "splendid triumphal arch, over which was perched a large figure of our proud, screaming American eagle, while the whole thing was set off to the nicest effect with evergreens and the national colors of the United States of America and the United States of Germany." The dates inside the two wreaths, 1813 and 1871, referred to Napoleon's entrance into Berlin in 1813 and to the German victory and the unification of a number of German states under Prussia.

Columbus constructed this city hall in 1872. This was the first building constructed in Columbus for the specific use of the city government. The public library was housed in this building until the Carnegie Library was constructed in 1906. The top floor served as a multipurpose room for basketball and other activities. The building was destroyed by fire in 1921 while the city council was in session. When a fireman told the councilmen that the building was on fire and to evacuate the building they did not believe him. However, when they smelled smoke they decided to leave.

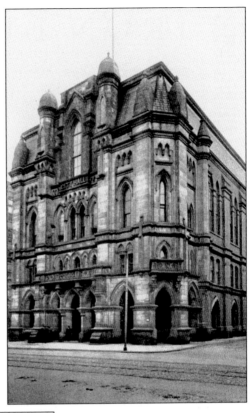

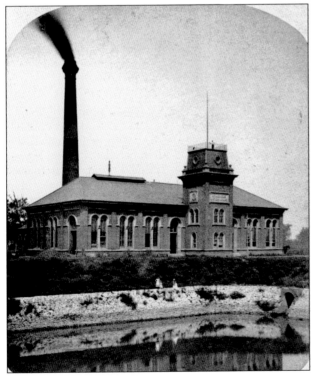

Columbus's first water works plant began pumping water on May 1, 1871. The water delivery system at that time consisted of a well and the Westside Pumping Station (shown here) built at the confluence of the Scioto and Olentangy Rivers. It served until replaced by a newer facility in 1908.

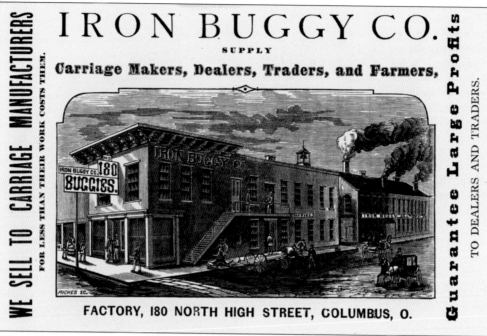

IRON BUGGY CO.

SUPPLY

Carriage Makers, Dealers, Traders, and Farmers,

WE SELL TO CARRIAGE MANUFACTURERS

FOR LESS THAN THEIR WORK COSTS THEM.

Guarantee Large Profits

TO DEALERS AND TRADERS.

FACTORY, 180 NORTH HIGH STREET, COLUMBUS, O.

Clinton D. Firestone and George M. and Oscar G. Peters formed the Iron Buggy Company in the early 1870s to produce low-cost buggies. This 1873 drawing shows the business which was located at High Street and Hickory Alley (which was between Spring and Chestnut Streets). The firm was successful, but Firestone and the Peters brothers sold the company in 1875 and formed a new company.

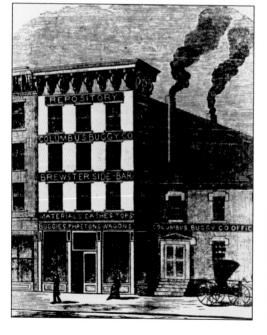

After Firestone and the Peters brothers sold the Iron Buggy Company, they formed the Columbus Buggy Company and opened a plant at Wall Street (one half block west of High Street) and Locus Street (one-half block south of what is now Nationwide Boulevard). This advertisement shows a drawing of their business in 1878, only a few years after it was begun. The Columbus Buggy Company grew to become one of the nation's largest buggy manufacturers.

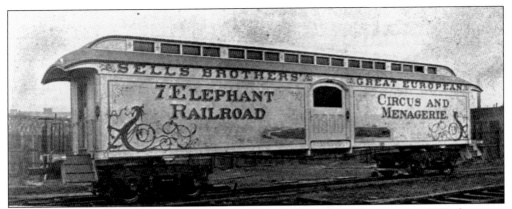

The four Sells brothers (Ephraim, Allen, Lewis, and Peter) formed a circus in 1872 that grew to become one of the largest traveling circuses in the country, rivaling the Ringling Brothers circus. In the early days, they traveled in standard railroad cars but later used specially built cars such as the one shown here. This car probably dates from the mid-1870s. The circus's winter quarters occupied most of the area bounded (today) by Fifth Avenue, Kenny Road, Kinnear Road, and the Olentangy River. The last of the Sells family's interest in the circus was purchased by the Ringling Brothers shortly after the death of the last of the Sells brothers in 1905.

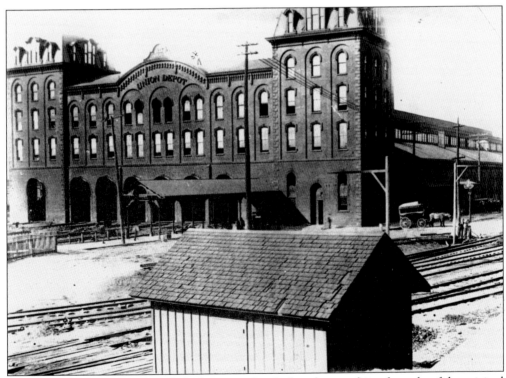

By the early 1870s, railroad traffic had increased such that the two through tracks of the original Union Station were inadequate. In 1875, it was replaced by Columbus's second Union Station, which provided six through tracks.

This was the first of three north end market houses that have served Columbus. It was constructed in 1875 on Vine Street, west of High Street, and served until it was destroyed by fire in 1948. Its replacement served from 1948 to 1995 when the current North Market opened at 59 Spruce Street.

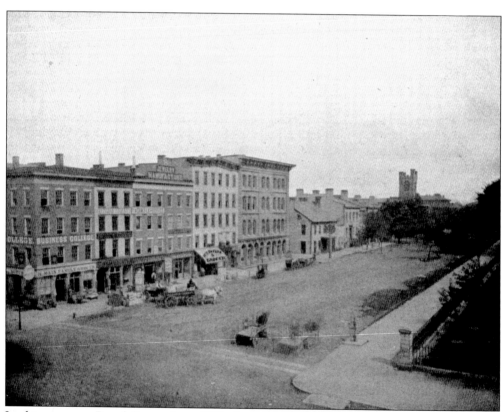

Looking east on Broad Street about 1875, the tallest building in the center of the picture is the Hayden-Clinton Bank building, erected in 1869. It is the only building in the picture that remains and is the oldest building on Capital Square. Just beyond the Hayden-Clinton building are residences and the tower of First Congregational Church.

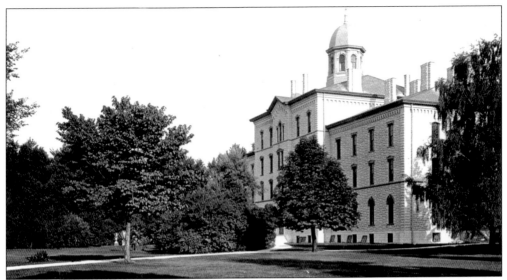

In 1876, a caravan of horse-drawn wagons moved Capital University from its former site on Goodale Street to a site on Main Street, just east of Alum Creek. This photograph shows Lehmann Hall, the first campus building at the new site. Completed in 1876, Lehmann Hall was razed in 1988.

The Columbus City Prison was built in 1879 on the northwest corner of Town and Scioto Streets; today that location would be near the northeast corner of Town Street and Civic Center Drive. In addition to serving as a prison, it was the headquarters of the Columbus Police Department. The building served until 1920 when it was destroyed by fire.

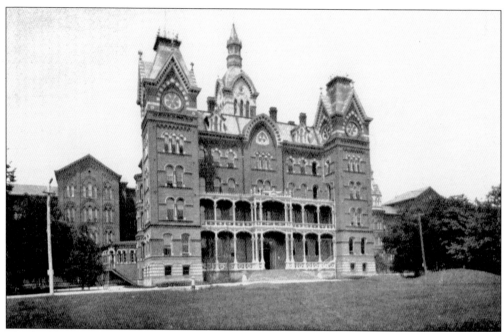

The building shown in this picture has gone by many names, including Central Ohio Lunatic Asylum, Imbecile Asylum, Asylum for the Insane, Central Ohio Hospital for the Insane, Columbus State Hospital, and Central Ohio Psychiatric Hospital. Located on the hilltop at 1960 West Broad Street, it replaced an older facility on the east side of Columbus that was destroyed by fire in 1868. This facility opened in 1877 and was razed in 1987.

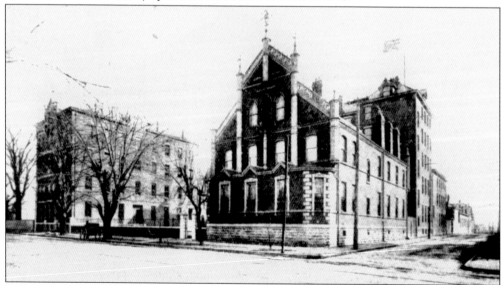

In 1877, Rev. Joseph Jennings relocated the St. Joseph's Orphan Asylum and its 17 orphans from Pomeroy, Ohio, to a brick house on Columbus's East Main Street at South Seventeenth Street. Between 1879 and 1898, 10 additional buildings were erected. In 1888, the program was enlarged to include a seminary, the College Josephinum. The Josephinum became the Pontifical College Josephinum in 1892, the only seminar in the Western hemisphere directly under the pope. In 1931, the Josephinum relocated to Route 23, north of Worthington.

Three

A DECADE OF GROWTH
(1880–1889)

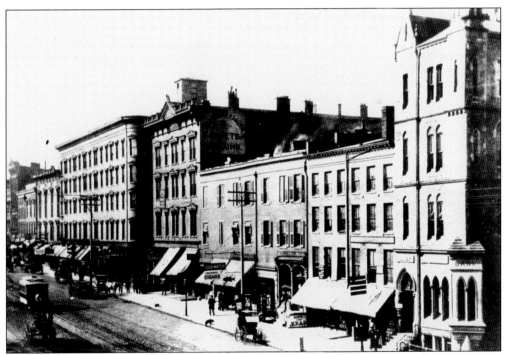

This view shows High Street looking south from Broad Street in the 1880s. The Huntington Bank is the tall but narrow five-story building to the right; the second Neil House hotel is the large five-story building on the left side of the picture. As the elevator was just coming into use, buildings of the time were limited to about five stories.

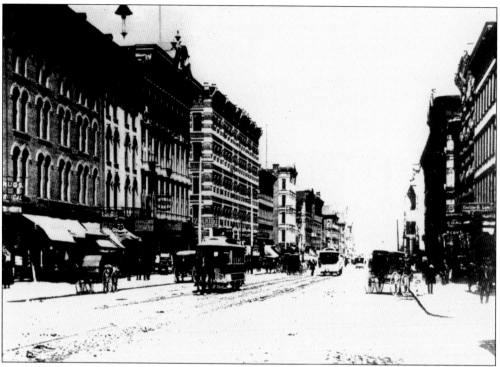

Looking north of High Street from Gay Street in the 1880s, one sees that horse-drawn streetcars were still the means of public transportation, while those that had horses and buggies used them to travel downtown. Houses built in the upper income neighborhoods during this period often had carriage houses to hold a horse and carriage, rather than garages. One disadvantage of the horses is that they had to eat, whether they were used or not.

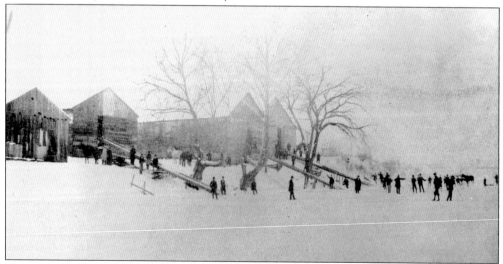

This photograph of men gathering ice on the Olentangy River dates to about 1880. In that day, the ice that formed on the river was important for preservation of foods, as well as providing a place to skate. Ice was cut during the winter and stored in sawdust-insulated underground caverns or cellars; then the ice could be used for keeping foods cool during the warmer months. Residents purchase ice from the ice man who provided door-to-door delivery with horse-drawn wagons.

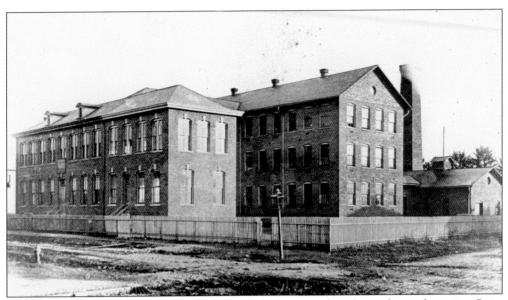

In 1874, Dietrich Gruen opened a watch shop in Columbus where he made watches using Swiss movements. In 1882, his Columbus Watch Company built this factory on the southeast corner of Thurman and City Park Avenues and began producing their own movements. In 1892, Gruen left the company; he moved to South Bend, Indiana, where he formed a new company. In 1903, the Columbus Watch Company was sold to Gruen's new company, and relocated to South Bend.

A parade was held in Columbus on July 20, 1883, in conjunction with the National Reunion of Ex-Soldiers and Sailors. It was reported that 150,000 watched the parade which included "widowed pensioners of 1776 and survivors of 1812," as well as representatives of later wars. Buildings, including the Ohio Furniture Company which the parade is shown passing, were decorated for the event.

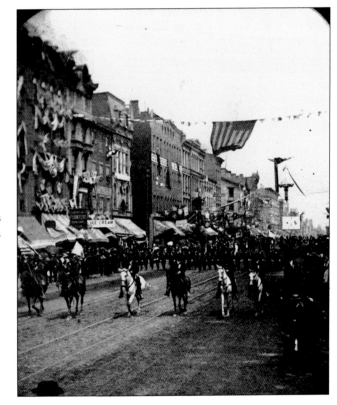

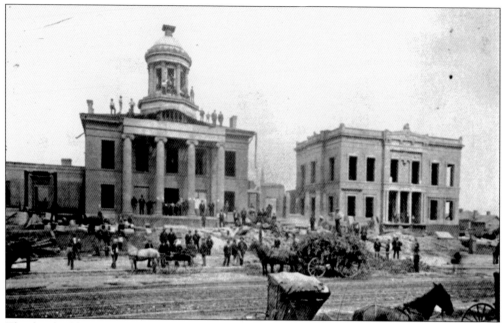

The first building erected in Columbus for specific use as a Franklin County Court House had been constructed in 1840 on South High Street at Mound Street. An annex was added later to the south of the original building. Both buildings were demolished in 1884 to clear the site for construction of a new court house.

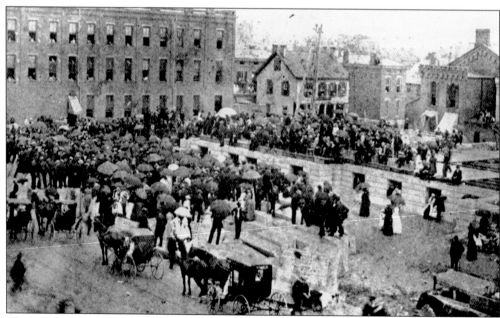

The cornerstone for the new Franklin County Court House was laid on July 4, 1885, with elaborate ceremonies.

The Franklin County's new court house was completed in 1887. It had an elaborate roofing structure with considerable ornamentation. This presented a problem over the years as joints opened and permitted rainwater to enter the building. Although it served until it was demolished in 1974, some of the gingerbread on the roof had been removed earlier. A model of this court house is displayed in the current courthouse.

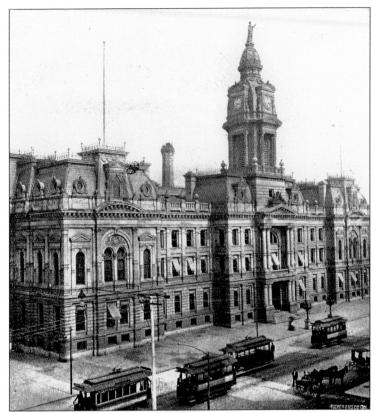

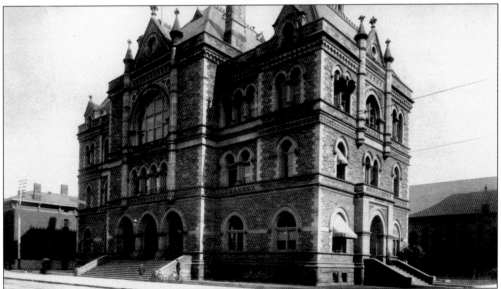

Construction of the U.S. Post Office and Custom House on the southeast corner of State and Third Streets was completed in 1887. At that time this building held all the federal government offices in Columbus. However, by the early 1900s, it was no longer large enough. Between 1907 and 1912, the post office and other government offices were moved to other buildings while this building was enlarged.

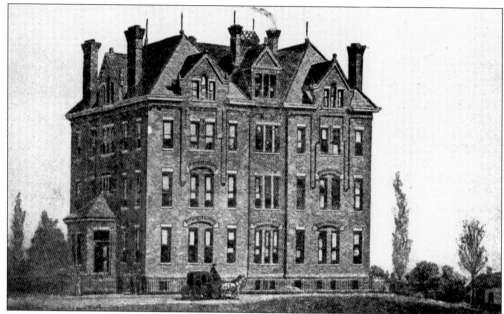

In 1885, Dr. William B. Hawkes and Dr. J. W. Hamilton initiated the building of a hospital on land donated by Dr. Hawkes. Dr. Hawkes died before the hospital was completed and it languished for lack of funds. Dr. Hamilton turned it over to the Sisters of Holy Cross from Notre Dame who completed the building and opened it in 1886 as the Hawkes Hospital of Mount Carmel. It later became known simply as Mount Carmel Hospital. Mount Carmel Hospital has continued to grow and is now one of the largest hospitals in central Ohio.

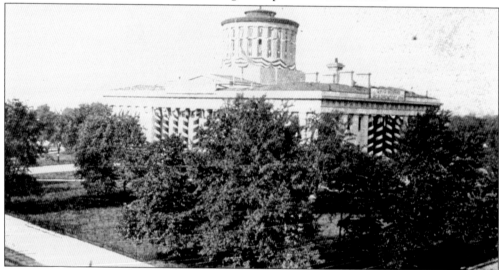

In July 1885, the state capital was once more draped in black, this time for one of Ohio's favorite sons—General Ulysses S. Grant. The sign over the entrance to the capital read, "Let us have peace." The sign over the south entrance read, "Ohio mourns her greatest son." Signs over the other entrances read, "The country is united at the bier of the dead" and "Harmony and good feelings between the sections." Over the entrance to the rotunda a sign proclaimed, "The nation that followed him while living with love and pride bows now in sorrow." Memorial services were held at Goodale Park and on the steps of the statehouse on the day Grant was buried.

This First Congregational Church had been built on the northwest corner of Broad and Third Streets as a brick structure in 1857. It was extensively remodeled and enlarged in 1886, including changing the brick front to stone, as shown here. Dr. Washington Gladden, who served as pastor of this congregation from 1882 until his death in 1918, was credited with developing the social gospel. The congregation moved to another site in 1931, and this building was razed in 1932.

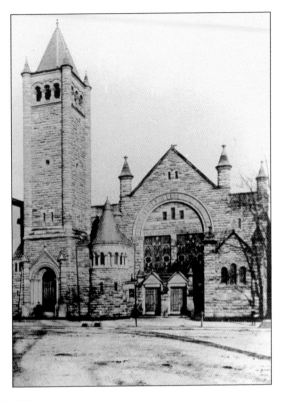

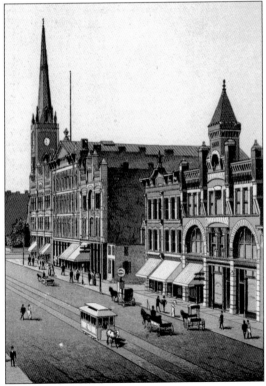

This 1888 drawing shows South High Street near the Franklin County Court House. It is a useful illustration of the types of buildings that existed during that era. The horse-drawn streetcars on High Street were not replaced by electric streetcars until 1891. The steeple that appears to arise from the building on the northwest corner of Mound and High Streets was actually the steeple of St. Paul's Lutheran Church on the southwest corner of that intersection.

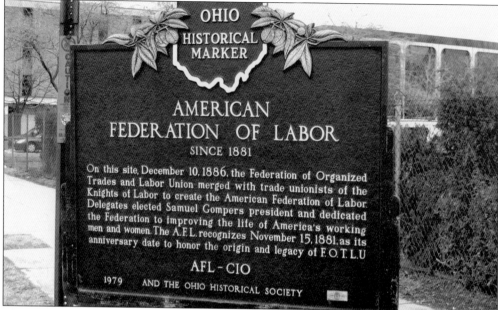

This historical marker, located on the east side of North Fourth Street between Rich and Town Streets, identifies the approximate location of where the American Federation of Labor, the nation's largest trade union, was founded in 1886. At this Columbus meeting, the American Federation of Labor evolved from the earlier Federation of Organized Trades and Labor Unions, and elected Samuel Gompers as its first president.

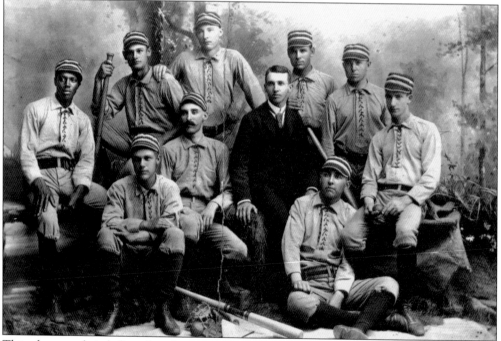

This photograph is believed to show the 1887 Columbus Buckeyes baseball team. This team is believed to have included the first African American to play for a professional Columbus baseball team. The Columbus Buckeyes played in the Ohio State League.

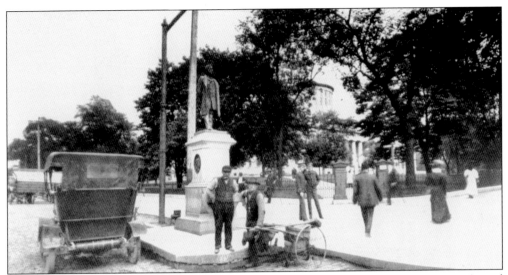

Dr. Samuel Mitchell Smith was dean of the Starling Medical College from 1849 to 1858 and 1860 to 1863, the first obstetrician in Columbus to administer chloroform during labor, and the first professor of psychiatry in the United States in 1847, teaching in Columbus. To honor Dr. Smith, a statue was sculpted by William Walcutt and dedicated on the southeast corner of Broad and High Streets in 1880. Because the statue jutted out into Broad Street, it was moved to the Starling Loving Medical College in 1915. The much traveled statue was moved to the Columbus Health Center on Washington Boulevard in 1957 and finally to a spot near the Neuroscience Building at the Ohio State University medical complex.

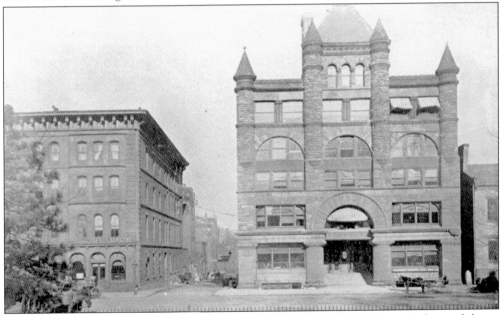

The Board of Trade Building was completed in 1889 at 30 East Broad Street. It featured dunce cap roofs, tourelles, and large columns. In 1909, the Board of Trade became the Columbus Area Chamber of Commerce. The building included an auditorium that was used for boxing matches and other events. The building was razed in 1969 to provide space for construction of the Rhodes State Office Tower. The Hayden-Clinton Bank is on the left.

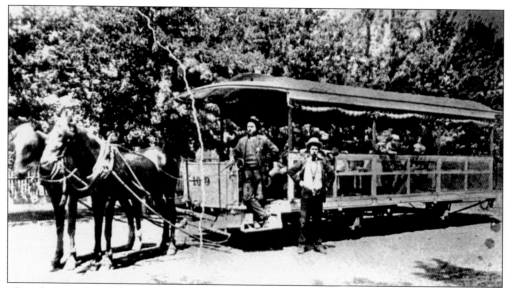

This photograph of a horse-drawn High Street streetcar is believed to date from about 1890. If so, it dates from the last year or so of horse- or mule-drawn streetcars, as they were replaced by electric streetcars beginning around 1891. The car shown here is a summer car with open sides.

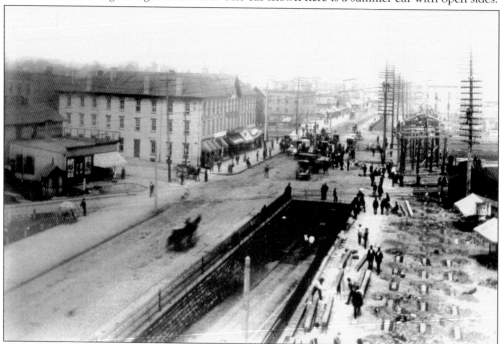

The large number of trains going through Columbus's Union Station each day caused considerable blockage of North High Street. To alleviate this problem, a streetcar tunnel was dug under the tracks. However, as the streetcars were still horse drawn the result was an odor problem in the tunnel. With the Grand Army of the Republic (GAR) Encampment and Ohio Centennial being celebrated in Columbus in 1888, it was necessary to come up with another answer. The solution was to build a temporary wooden viaduct for the streetcars. This photograph shows both the entrance to the tunnel and the construction of the wooden viaduct.

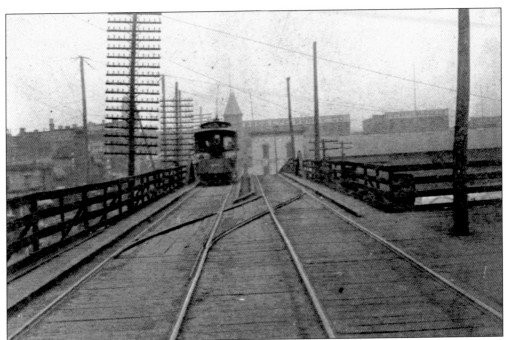

Although the wooden viaduct at Union Station was constructed as a temporary facility, it was used for several years until a new Union Station with an earthen viaduct was constructed. This early-1890s photograph shows an electric streetcar passing over the viaduct.

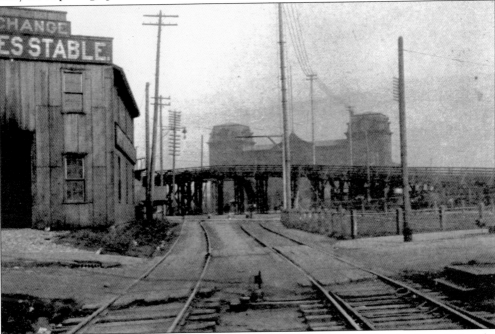

This view, looking east from west of High Street, shows the wooden viaduct in place. Before the viaduct was in place it was reported that trains blocked High Street at Union Station for over eight hours each day. This hindered development of Columbus to the north. Once the railroad problem was solved, the north side developed rapidly.

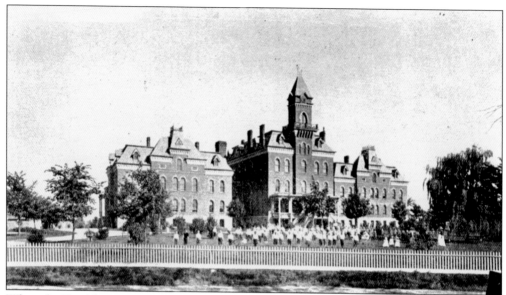

When the Franklin County Children's Home opened in 1888 it was on the outskirts of the city in an area now bounded by Sunbury Road, Maryland Avenue, Nelson Road, and Interstate 670. It provided a home for children with no parents, or whose parents and relatives could not provide for them. In 1951, the orphanage was relocated to a new facility at Gantz and Frank Roads.

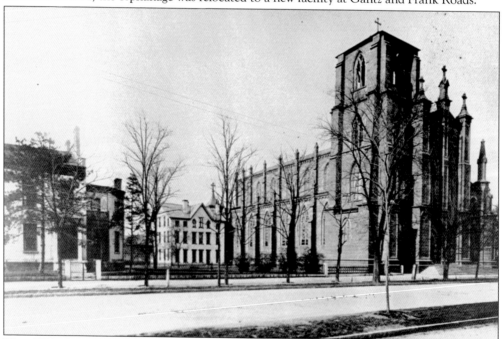

This 1889 photograph shows the St. Joseph's Roman Catholic Cathedral, rectory, and bishops house. Construction had begun for a parish church, but when Columbus was made a diocese and a bishop assigned here, the foundation was torn out and the cathedral was built on the site. Although the building was not finished, the first service was held on Christmas Day, 1872. In 1879, the William G. Deshler house at 198 East Broad Street became the bishop's residence. The cathedral is located at 212 East Broad Street.

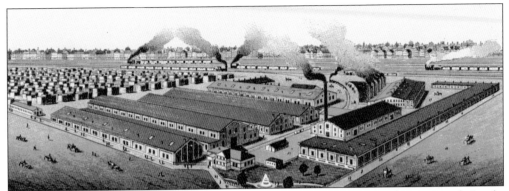

A family hardware merchandising business was reorganized as Kilbourne and Jacobs Manufacturing Company in 1881. This 1888 picture shows the main shops of the Kilbourne and Jacobs Manufacturing Company at Russell and Warren Streets. They manufactured steel and drag scrappers, plows, road graders, wheelbarrows, steel sinks, railroad and warehouse trucks, baggage barrows, and so forth. The company closed in 1923.

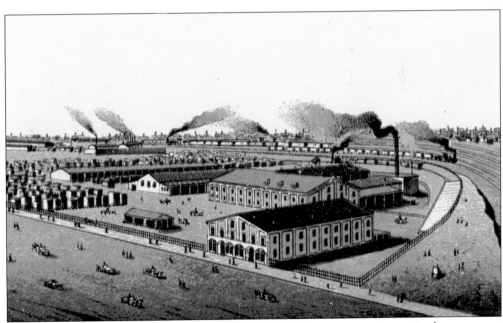

Kilbourne and Jacobs was the largest manufacturer of earth moving equipment in the country at the end of the 19th century. This 1888 era picture shows the extent of their wheelbarrow works on Lazelle Street.

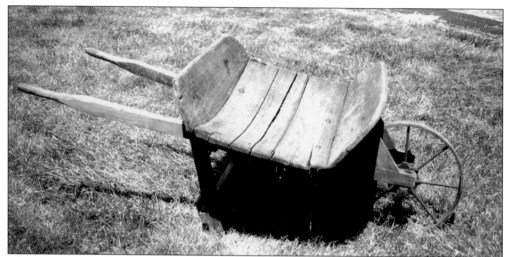

Although the Kilbourne and Jacobs manufacturing plant is long gone from the Columbus scene, occasionally one of their products shows up at an antique show or auction. This Kilborne and Jacobs wheelbarrow was photographed at an antique show in 1986. The asking price was $150.

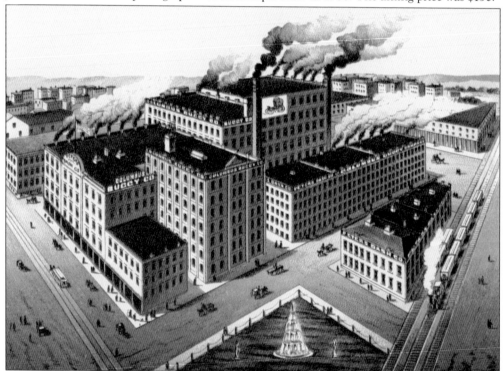

This 1888 drawing shows the facilities of the Columbus Buggy Company from the northeast (from over Union Station) looking toward the southwest. By this date, the company had expanded to occupy essentially the entire block between Naghten Street (now Nationwide Boulevard) and Locus Street, and between High Street and Wall Street. In 1892, it was reported that they employed 1,200 persons and built 100 vehicles and 1,500 carriage dashes a day. A brochure from the Chicago World's Fair in 1893 shows the company had dealerships in every state and shipped buggies overseas.

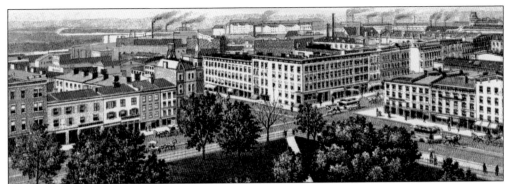

This 1888 view looks northwest from the state capital dome across the intersection of Broad and High Streets. The building on the northwest corner of the intersection is the Deshler Block. Above it can be seen the Ohio Penitentiary. In that period, smoke from factories was interpreted as a sign of people being employed and prosperity, not air pollution.

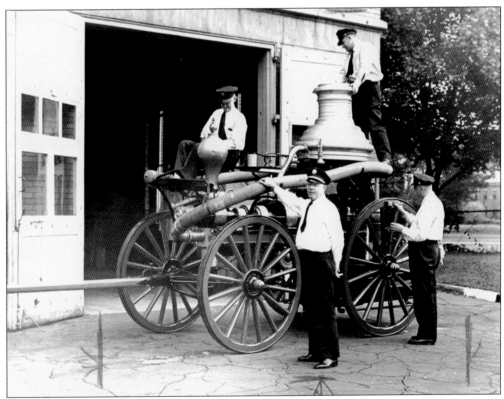

In 1855, Columbus became only the fourth city in the nation to adopt a paid steam fire department. This 1942 photograph shows Columbus firemen inspecting an early steam engine used to pump water for fighting fires in the 1880s. The engine was being readied for a fire prevention display.

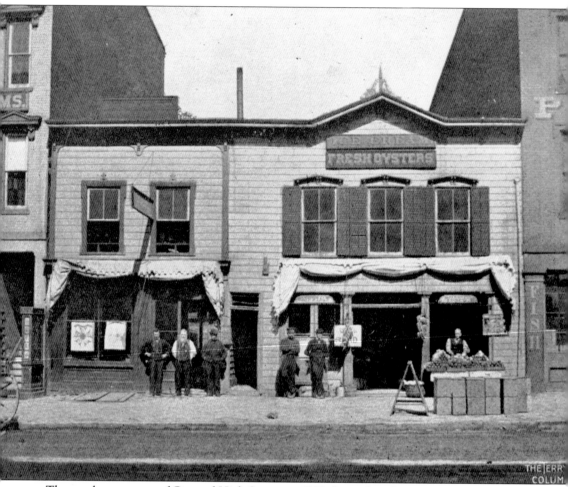

The northeast corner of Gay and High Streets in 1888 shows that there were still small business buildings near the heart of downtown, even though Columbus had grown into a significant and busy city. Within a few years these stores would be replace by four and six story buildings. Fresh oysters were being offered in one of the stores; probably shipped in by train from the east coast.

Four

COLUMBUS CELEBRATES
(1888)

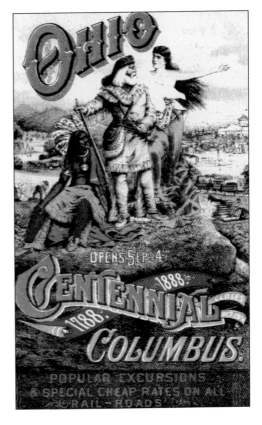

This poster-style card was used in advertising the Ohio Centennial Celebration in Columbus in honor of the 100th anniversary of the first settlement in Ohio (at Marietta). In Columbus, the annual five-day Ohio State Fair was replaced by the seven week (September 4 through October 19) Ohio Centennial Celebration which was held at the Ohio State Fairgrounds. Simultaneous with the Ohio Centennial Celebration, the Grand Army of the Republic held its 22nd National Encampment (reunion) in Columbus from September 10–14.

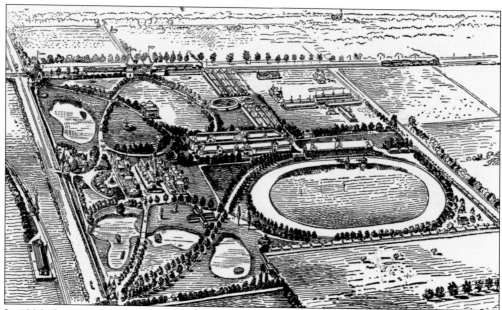

In 1886, the Ohio State Fair had been moved from Franklin Park to a location about two miles northeast of the state capital building—the present Ohio Exposition site. This drawing shows the fairgrounds at the time of the Centennial Celebration. Out-of-town visitors could enter the fairgrounds through the train stop on the west side of the fairgrounds. Local visitors could come on streetcars via High Street and Eleventh Avenue.

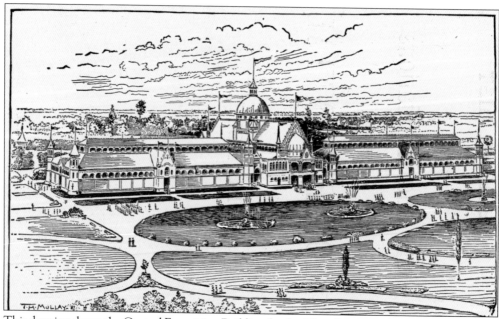

This drawing shows the Central Exposition Building for the Ohio Centennial. As can be seen from the previous drawing, it was the largest building at the fairgrounds and was centrally located.

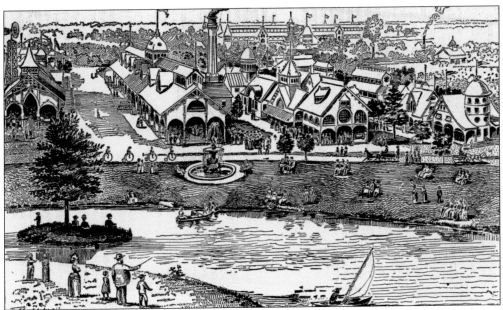

This drawing shows the building used for machinery exhibits during the Ohio Centennial.

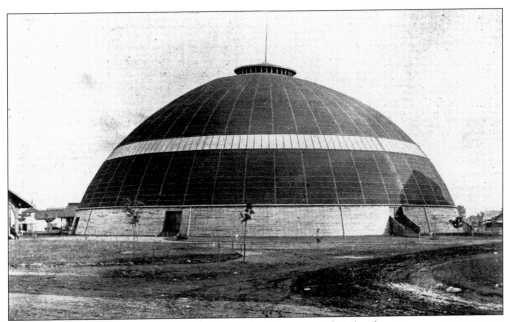

The Centennial Auditorium was built of wood and was considered to be a temporary structure. It was 200 feet in diameter, 86 feet high, and could seat 10,000 persons. Shortly after the close of the centennial, it was torn down for its salvage value.

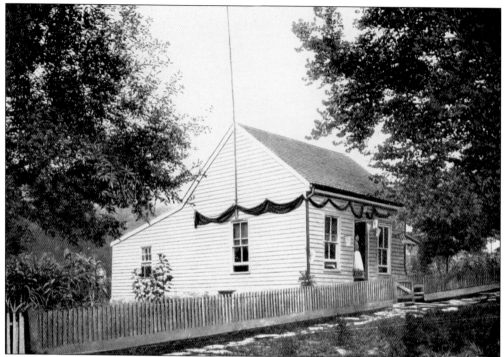

The cabin in which Ulysses S. Grant was born in Point Pleasant, Ohio, was brought by train to the fairgrounds in Columbus for the opening of the Ohio Centennial. The move was funded by Henry T. Chittenden, owner of the Chittenden Hotel. The cabin was returned to Point Pleasant in 1927.

While at the Ohio State Fairgrounds, the Grant Cabin was encircled by a structure designed to preserve it. The cabin is within the structure shown in this photograph.

This view, looking north on High Street from Rich Street, shows the Metropolitan Opera House decorated for the Grand Army of the Republic Reunion, including signs proclaiming "Welcome Veterans." The Opera House, located at 197 South High Street, was Columbus's major theater and was also known as the Cotton Block and as Comstock's Opera House. It was built in 1862 and was destroyed by fire in 1892.

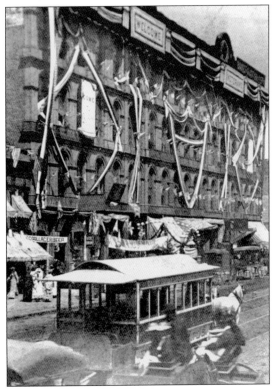

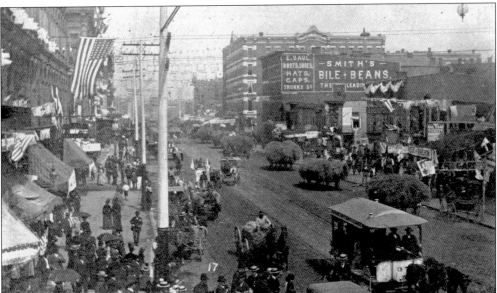

Columbus did not have facilities (hotels, and so forth) to accommodate the 50,000 Union veterans expected for the Grand Army of the Republic Encampment. Thus, thousands of tents were set up at four camps. The Straw Parade featured 60 wagonloads of straw donated by farmers for use by the veterans encamped around Columbus. Final reports were that 100,000 veterans and 150,000 wives, children, and friends attended. The population of Columbus at the time was about 102,000.

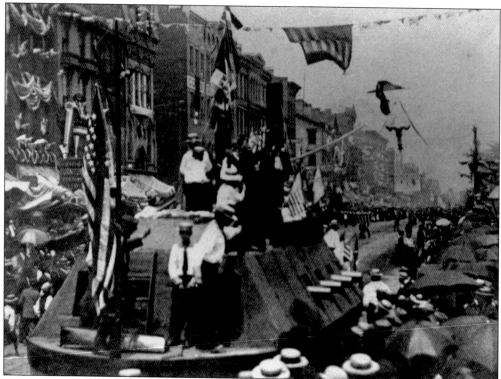

A float recreating an image of the Merimac moves down High Street during the Parade of the Grand Army, one of the activities during the Grand Army of the Republic Encampment.

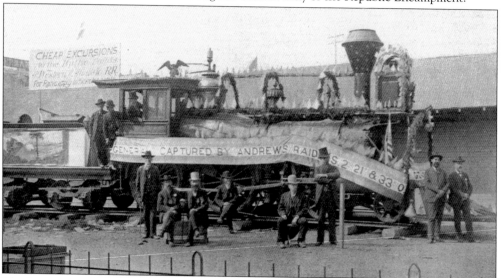

The locomotive *General* was brought to Columbus for the 1888 Grand Army of the Republic Encampment. A group of mostly Ohio soldiers captured the *General* at Big Shanty, Georgia, in 1862 and ran north to link up with the Union Army. They cut telegraph wires and tore up track along the way to delay pursers and to disrupt the Confederate use of the rail line. However, aggressive pursuit by the train engineer and others resulted in the capture of all 22 Union soldiers. Seven were hanged, but others either escaped or were exchanged for Confederate prisoners.

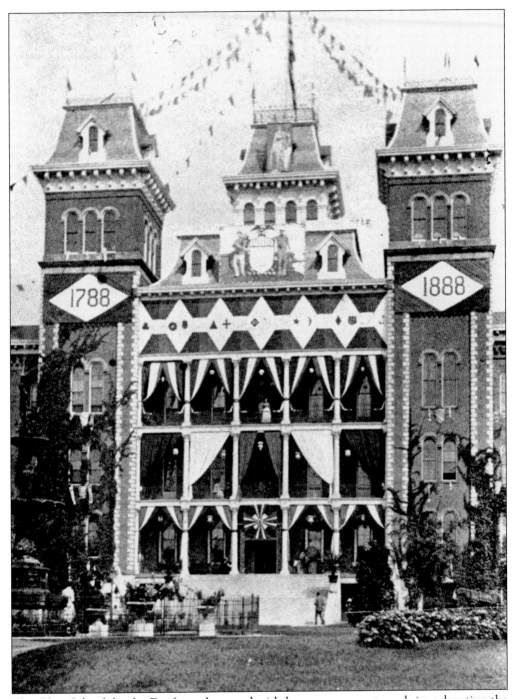

The Ohio School for the Deaf was decorated with banners, pennants and signs denoting the 1788 and 1888 Centennial years.

The opening parade of the Ohio Centennial is shown as it came north on High Street and turned east on Broad Street.

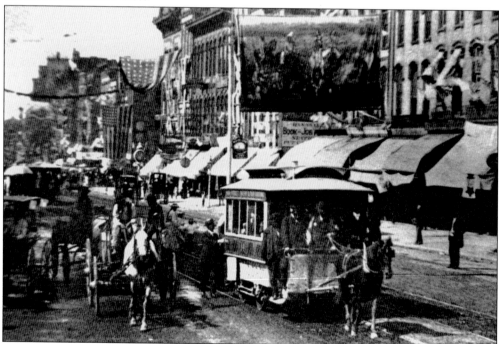

Columbus was alive with activity and decorations during the Ohio Centennial Celebration. A pictorial banner and flags hang over High Street and the fair-bound streetcar is full to the extent that passengers are crowding the driver.

Five

TO THE END
OF THE CENTURY
(1890–1899)

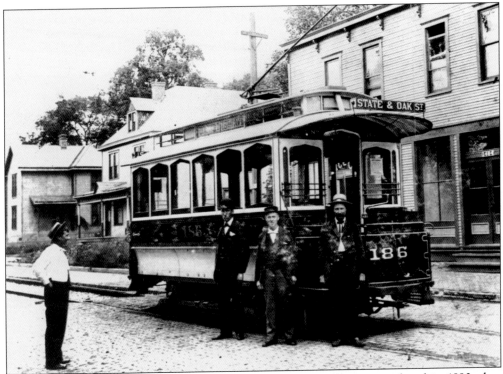

Columbus made a major step forward when electric streetcars were introduced in 1890; they replaced the horse or mule powered streetcars on High Street in 1891. Some persons have called the streetcar the single most important technical development of the late 19th century, as it freed people from dependence on horses or their feet. This streetcar shown here was a dinghy, a four-wheel streetcar for lightly traveled routes. Larger, eight-wheel cars were used where traffic was heavier.

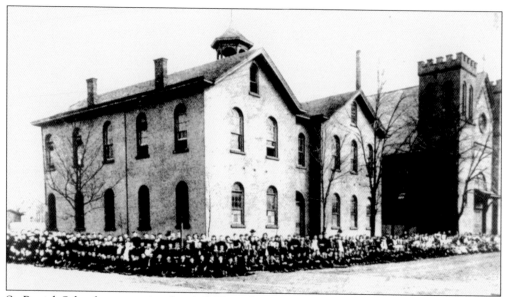

St. Patrick School was associated with St. Patrick's Catholic Church, which had been established in 1852 at Seventh Street (now Grant Avenue) and Naghten Street. The church was to serve English speaking (largely Irish) Catholics while an existing church (Holy Cross) would continue to serve German speaking Catholics that lived in the southern part of Columbus. The first school building was erected in 1854 and an addition was completed in 1863. This 1890 photograph shows the students of St. Patrick's school assembled in front of the building.

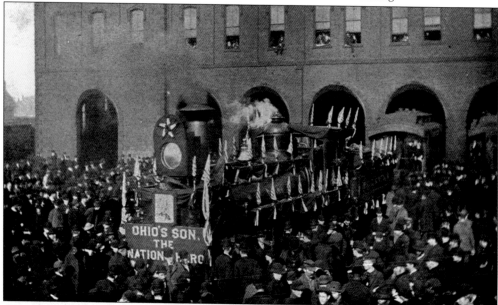

Gen. William Tecumseh Sherman's funeral train passed through Columbus's Union Station on its way from New York City, where Sherman died on February 14, 1891, to St. Louis where he was buried. When the heavily draped and decorated engine and eight-car funeral train reached Columbus it was greeted by the solemn booming of cannons and a crowd of 10,000 persons who had assembled at the station to honor this son of Ohio. Two Ohio National Guard Regiments and a committee of politicians travel to St. Louis for the funeral.

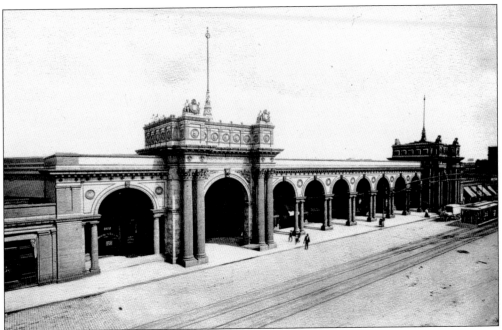

In 1893, a permanent solution was sought to the problem of High Street being intersected by the railroad tracks at the Union Station. Famed Chicago architect Daniel Burnham designed a new Union Station which was erected at the same location as previous stations (where the Convention Center is now located). Most people refer to the scene pictured here as Union Station. Actually, this view only shows a façade along High Street that contained the entrance to Union Station and a few shops.

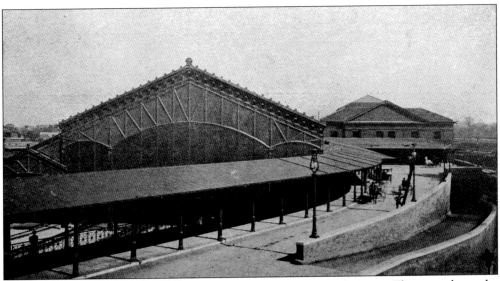

The actual train station was located about one block east of High Street. This view shows the station and train shed as constructed in 1893. In 1930, the train shed was replaced by a series of covered walkways that provided access to the trains.

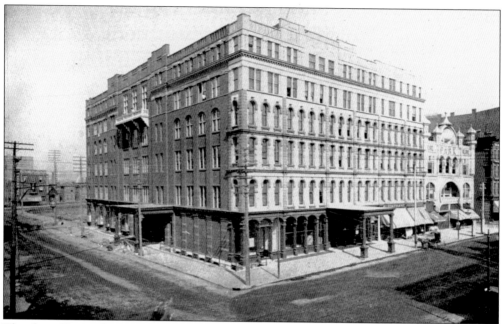

The first Chittenden Hotel opened in 1892 in a renovated and enlarged business block (the Parker Building) on the northwest corner of High and Spring Streets.

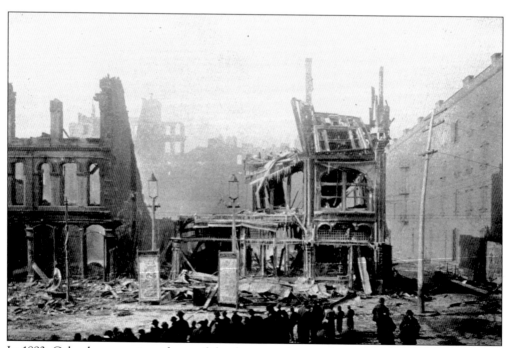

In 1893, Columbus experienced one of the downtown's most destructive fires. The Chittenden Hotel and two theaters were destroyed. Fortunately, there was only one life claimed by this fire.

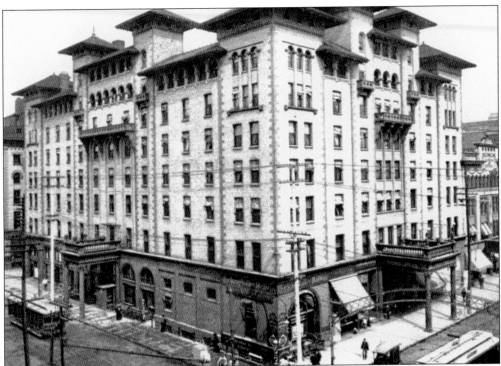

The second Chittenden Hotel was constructed using 97 percent noncombustible material. The new eight-story Chittenden Hotel with 300 guest rooms opened in 1895 and was closed in 1972. The building was razed in 1973. Although not shown in this view, for many years, a sign picturing a jumping purple cow on the High Street side of the hotel advertised the Purple Cow coffee shop.

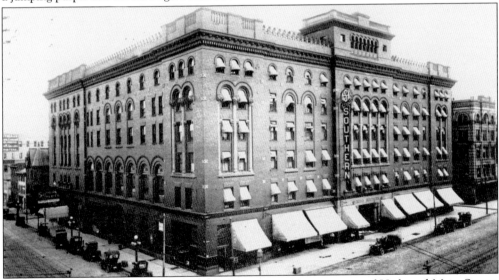

The Southern Hotel was completed in 1896 on the southeast corner of High and Main Streets to provide a hotel for the south end of downtown Columbus. Its construction followed several major fires in Columbus, including the Chittenden Hotel fire. Thus, it was important to design the building to be as fireproof as possible, and this fact was used in promoting the hotel. It is the oldest operating hotel in Columbus. Restored in 1985, it now operates as the Westin Southern Hotel.

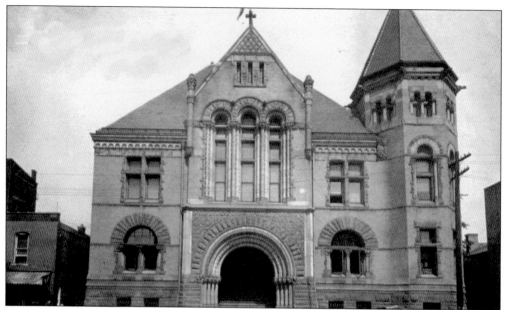

The building shown here was originally the Town Street Methodist Episcopal Church at 40 East Town Street. The church was built in 1853. In 1892, after the congregation had moved to another location, the school board purchased the building and the Public School Library and the administrative offices of the Columbus Board of Education were moved into it. It was used for school functions until 1928 when it was razed.

The North Side High School building (later North High School, Everett Junior High School, and Everett Middle School) is shown in a picture from about the time of its opening in 1893. This was the second high school in Columbus and its opening resulted in what was then the original high school being renamed Central High School. This building, located at 100 West Fourth Avenue, served as North High School until a new North High School opened in 1924.

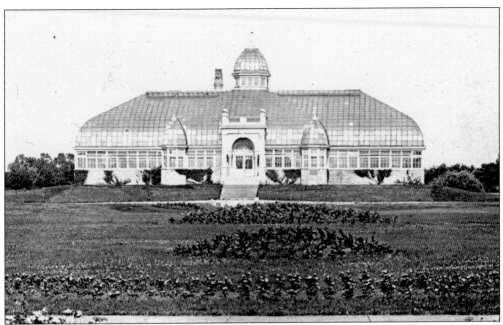

The Franklin Park Conservatory was modeled after a similar, but much larger, structure at the World's Columbian Exposition in Chicago in 1893. The conservatory was opened in 1897. For a period between 1927 and 1930, some animals were kept on the lower level of the conservatory during the winter because the Columbus Zoo did not yet have heated quarters. In 1991, the conservatory was enlarged in preparation for AmeriFlora'92.

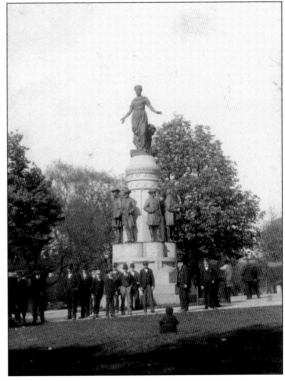

After being displayed at the 1893 World Columbian Exposition, the Our Jewels Monument was moved to the state house grounds in Columbus. Designed by Levi Tucker Scofield, the monument honored seven Ohioans who contributed significantly to the Union effort during the Civil War: Salmon P. Chase, James A. Garfield, Ulysses S. Grant, Rutherford B. Hayes, Philip Sheridan, William T. Sherman, and Edward M. Stanton.

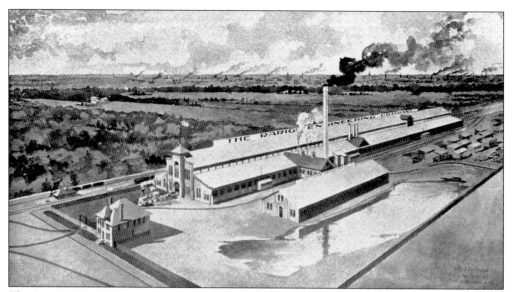

The Rarig Engineering Company was established in Columbus in 1858. In 1896, they occupied the new plant shown in this picture in East Columbus, just south of East Fifth Avenue at Rarig Avenue.

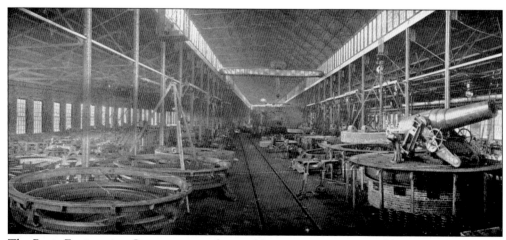

The Rarig Engineering Company manufactured large steam engines and heavy steel structural products including steam engines, 90-foot, 30-ton bridge girders, structural work for blast furnaces, and the carriages for 12-inch coastal defense guns, shown here.

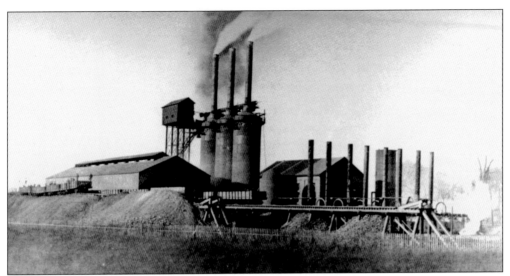

This photograph shows three blast furnaces on High Street in Steelton (the heavy industry area on the south side of Columbus near the railroad tracks). These steel works are identified variously as the Works of the Carnegie Steel Company and as the Columbus Steel Works. The earliest references date to 1894.

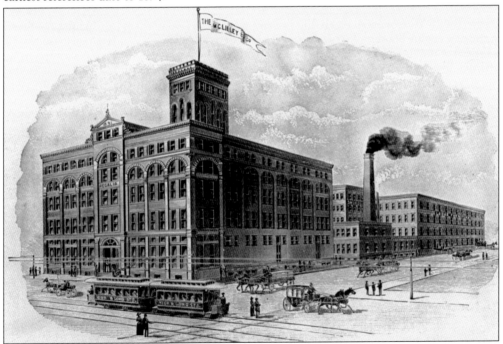

The M. C. Lilley Company was organized about 1865 to publish the *Odd Fellows Companion* for the International Order of Odd Fellows. They later expanded to producing fraternal items for various lodges and societies. Their need for more space was solved by constructing this building at 87 North Sixth Street in 1891–1892. In 1897, the company employed 700 persons. However, business began declining during the Depression and the company (by then the Lilley-Ames Company) moved from this building in 1950 and ceased operation in 1953. The building was razed in 1973.

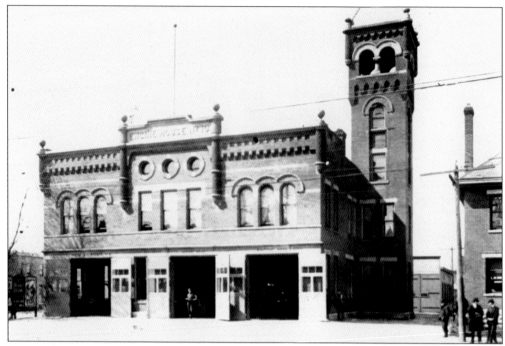

During the 1890s, Columbus erected 10 new fire stations and enlarged an existing station. Some of the new engine houses were two bay and others were three bay houses. Engine House No. 10 is typical of the three bay engine houses. These engine houses were constructed with towers in which hoses could be hung to dry. Constructed at 1102 West Broad Street in 1897, Engine House No. 10 is the oldest fire station in Columbus that is still in use as an active fire station. It is due to be replaced soon.

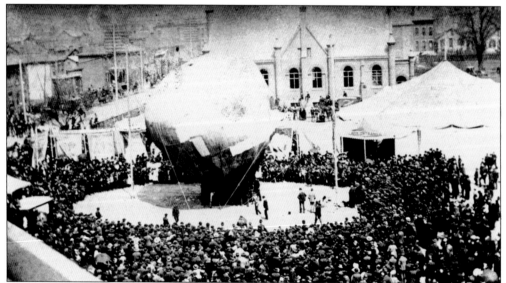

Although this photograph of an early balloon ascension in Columbus is not dated, it probably dates from the 1890s. The church in the background, the Welch Presbyterian Church, was built in 1888. The first recorded balloon ascension in Columbus occurred on July 4, 1842, when Richard Clayton of Cincinnati traveled from Columbus to a point five miles east of Newark.

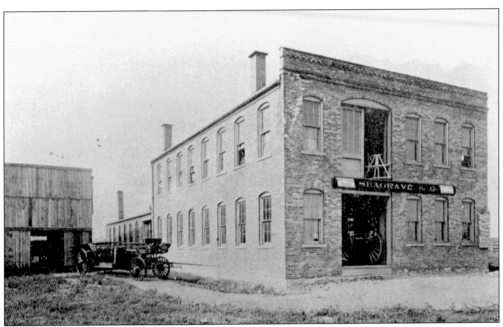

The Seagrave Company began business in Michigan by making ladders for apple orchards. Because of the high quality of their ladders, they became a supplier of ladders for fire departments. In 1896, they relocated to the Columbus area, occupying this small building shown on West Lane Avenue at the railroad crossing.

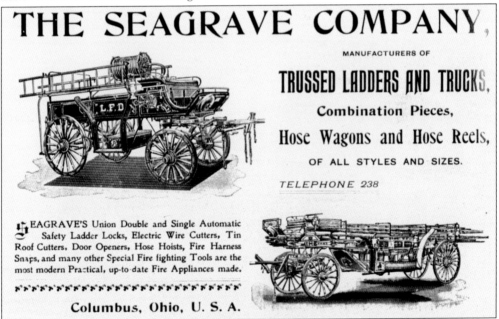

THE SEAGRAVE COMPANY,

MANUFACTURERS OF

TRUSSED LADDERS AND TRUCKS,

Combination Pieces,

Hose Wagons and Hose Reels,

OF ALL STYLES AND SIZES.

TELEPHONE 238

SEAGRAVE'S Union Double and Single Automatic Safety Ladder Locks, Electric Wire Cutters, Tin Roof Cutters, Door Openers, Hose Hoists, Fire Harness Snaps, and many other Special Fire fighting Tools are the most modern Practical, up-to-date Fire Appliances made.

Columbus, Ohio, U. S. A.

This late 1890s advertisement for Seagrave fire equipment shows that they offered horse-drawn hose, hose reel wagons, and ladder trucks. In addition to this equipment, fire departments would need steam powered engines to pump the water. Horse-drawn fire equipment continued to be used even after motorized equipment became available. It was not until 1921 that Columbus's fire department was completely motorized.

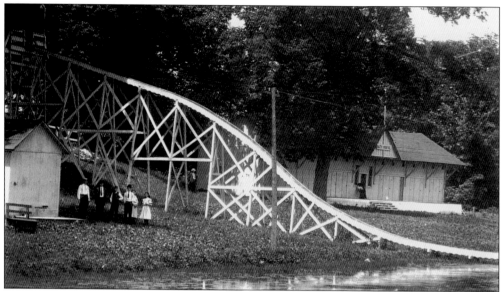

Minerva Park opened as an amusement park in 1896. Located south of Dublin-Granville Road between Cleveland Avenue and Westerville Road, the park offered picnicking, dancing, boating and a few amusement rides. The park was reached via the streetcar line that ran to Westerville and passed through the park. One attraction at Minerva Park was the water slide shown here. Riders could slide down the chute and into the pond.

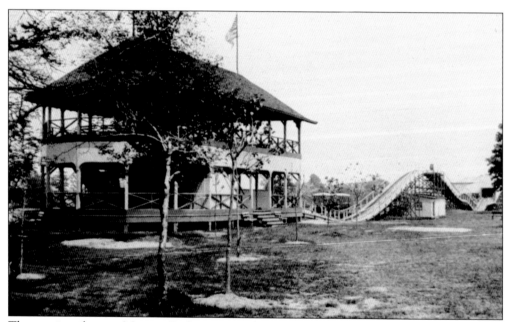

The scenic railway at Minerva Park was an early roller coaster. Judging from the height of the doorway to the shed, the hump must not have been more than about 20 feet. It is not evident how the car was returned for subsequent trips.

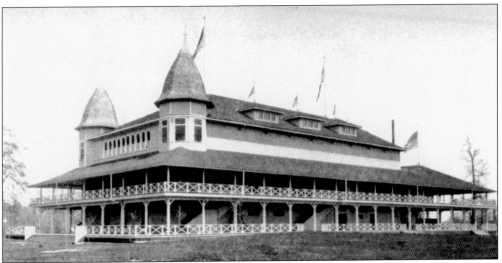

This photograph shows Minerva Park's casino. It was not a gambling house; rather it was essentially a ballroom and was used for programs and dancing. Minerva Park failed after only seven years because it was too far out in the country and newer parks opened closer to the city. In the 1930s, Minerva Park was sub-divided and became a suburban housing area.

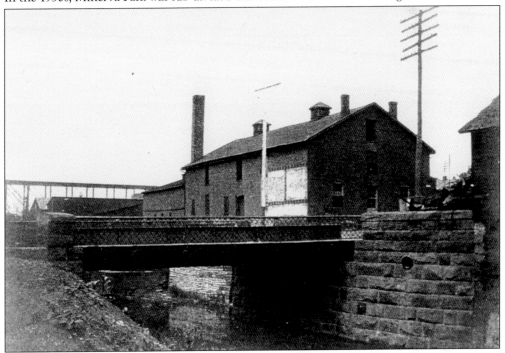

In the 1830s, two canals were constructed linking Lake Erie to the Ohio River and providing transportation to and from towns along their paths. Columbus was not on either of these canals. However, a Feeder Canal was constructed from Lockbourne to Columbus so that Columbus had access to the cheap canal freight rates. After the railroads became widespread (in the 1850s and 1860s) the canals diminished in importance. This 1899 photograph shows a portion of the Feeder Canal in downtown Columbus after the canal had been largely abandoned. Ohio's canal system was finally destroyed by the 1913 flood.

The Scioto and Olentangy Rivers have been a constant flood threat to Columbus, especially to the former Franklinton area west of the Scioto River. This area is frequently referred to as "the Bottoms." In 1898, Columbus experienced its most severe flood to date when the Scioto River overflowed into the Franklinton area (which by then had been annexed to Columbus).

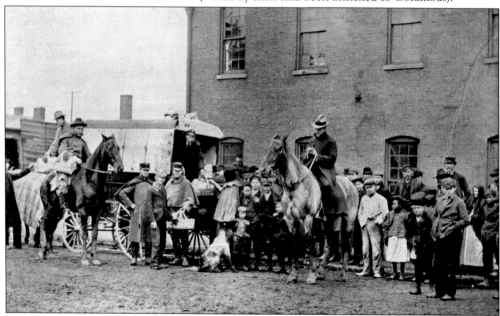

Dr. Gunsaulus organized a relief corps to distribute provisions to victims of the 1898 flood that were in immediate need. The dog in the center of the group is Joe; reportedly he awakened the occupants of a house on Short Street, thus saving the lives of a mother and two small children.

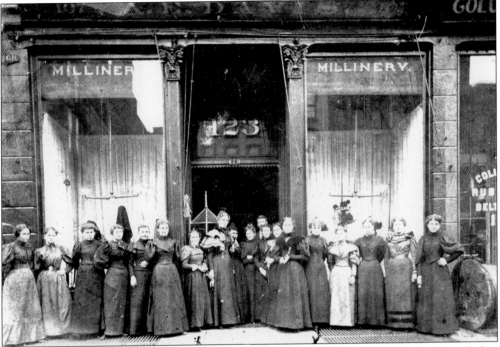

This 1890s photograph shows the staff of a millinery shop at 123 South High Street. Some ladies hats are visible in the store window to the right. The store window displays appear to have gas lamps, suggesting that the store was open during non-daylight hours.

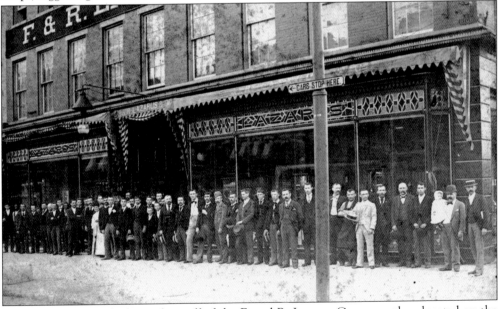

An 1890s photograph shows the staff of the F. and R. Lazarus Company, then located on the southwest corner of Town and High Streets. At that time, Lazarus only sold clothes for men and boys. In 1908, they determined to also sell clothes for women and girls, as women were starting to purchase ready-made clothes, rather than purchase material and sew their own clothes. Thus, they moved to a larger store on the northwest corner of Town and High Streets.

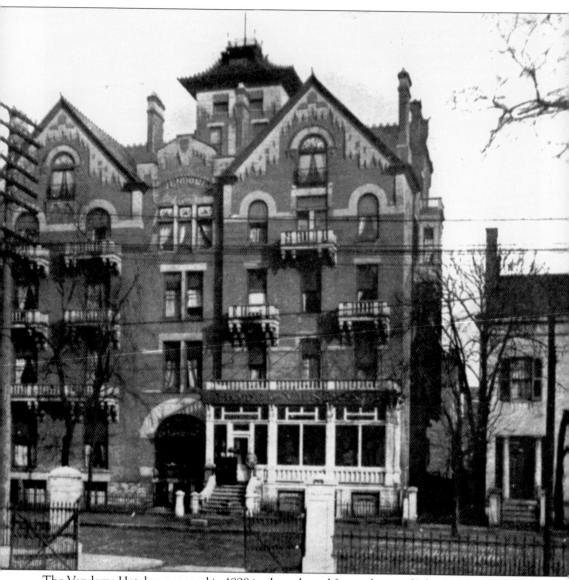

The Vendome Hotel was opened in 1898 in the enlarged former home of John Noble at 60 South Third Street. Noble was a hotel manager and a politician, serving on city council and in the Ohio senate. In 1918, the YWCA purchased the building. The former Vendome Hotel building was demolished in 1932.

Six

A NEW CENTURY
(1900–1910)

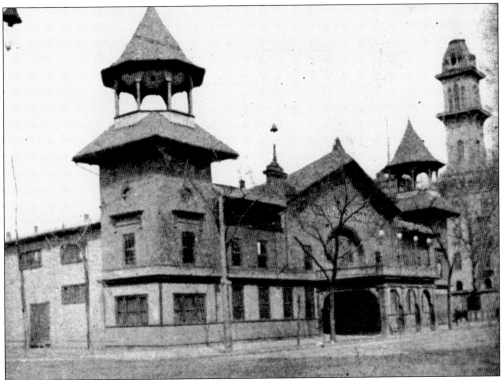

This 1901 photograph shows the Columbus Auditorium located on the northeast corner of Park and Goodale Streets. Originally opened in 1885 as the Park Roller Skating Rink, it was extensively remodeled by Columbus architects Yost and Packard to become the Columbus Auditorium. The auditorium opened on June 24, 1897, and collapsed under a heavy snow load February 18, 1910.

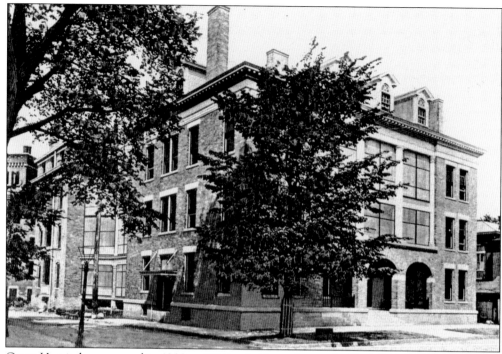

Grant Hospital was opened in 1900 at 125 South Grant Avenue by Dr. J. F. Baldwin. His original intention was to provide care for his private patients, but the hospital's accommodations were later made available to other physicians. The facility continues to be updated with new or replacement buildings and Grant Hospital continues to be one of Columbus's major medical facilities.

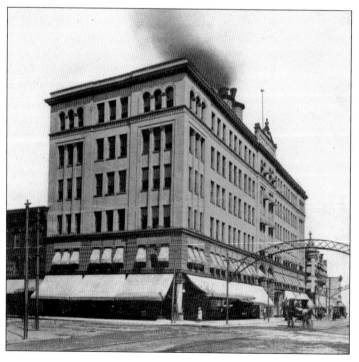

The Hartman Hotel was constructed as a manufacturing building in 1898 as one of the ventures by Dr. Samuel B. Hartman. It was converted to a hotel in 1901. After closing as a hotel in 1921, it was renamed the Ohio Building and housed state offices and later a bank on the first floor. After 1995, it sat idle until it underwent extensive renovation and was reopened in 2002. It now hosts special events in the Grand Hartman Ballroom and the Metropolitan Grand Loft.

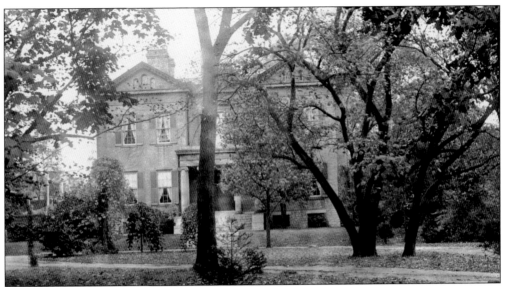

The former residence of George McClelland on the northeast corner of Parsons Avenue and Bryden Road was the home of the Columbus School for Girls from 1901 to 1953. The house was razed in 1954.

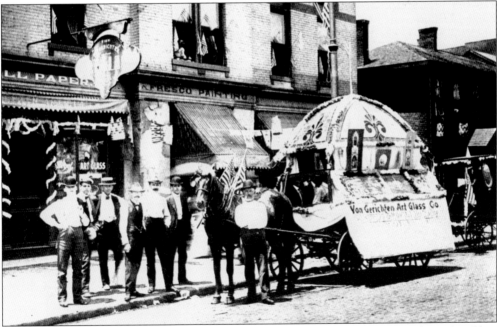

Ludwig von Gerichten moved to Columbus in 1894 and formed the Von Gerichten Art Glass Company. His brother, Theodore, then joined him and together they built an artistically and financially successful business. Von Gerichten art glass windows won the grand prize and four gold medals at the 1904 Louisiana Purchase Exposition. By 1931, the brothers parted and the company ceased to exist. Over the years the company produced approximately 1,800 stained glass windows for 853 different churches. A number of Columbus churches have their windows. This photograph shows a stained-glass float that the company placed in the Schiller Day Parade in 1905.

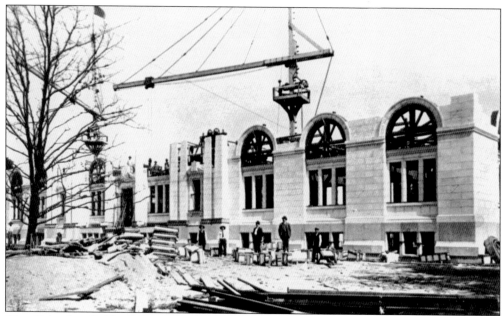

The Columbus Public Library (now the Columbus Metropolitan Library) was constructed between 1903 and 1906 at 96 South Grant Avenue. Construction of the Columbus Public Library had proceeded to the top of the first story windows when this photograph was taken in October 1904. The library opened in 1906 and remains in this facility, although a major expansion was completed in 1991.

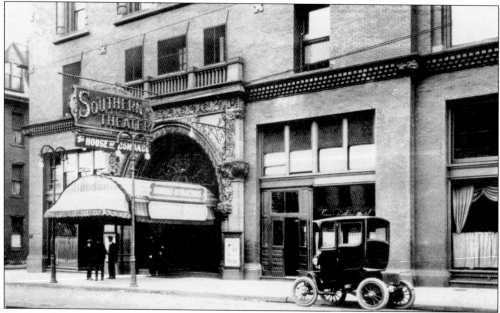

The Southern Theatre had been constructed with the Southern Hotel in 1896. This photograph shows the Southern Theatre in the first decade of the 20th century. The automobile parked near the theater was an electric car. Automobile manufacturers advertised electric cars for women because these vehicles did not require cranking as did gasoline cars, they did not require shifting gears or adjusting spark settings, and because they were quiet.

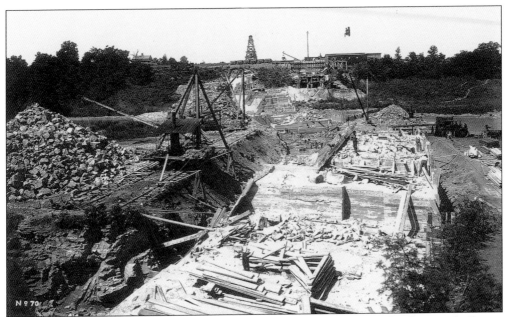

As Columbus grew and the need for a reliable water supply was recognized, a dam on the Scioto River seemed necessary. This photograph shows work underway to build a dam on the Scioto River. The dam was originally called the Storage Dam, however, in 1922, it was renamed Griggs Dam in honor of Julian Griggs, the city engineer at the time the dam was constructed.

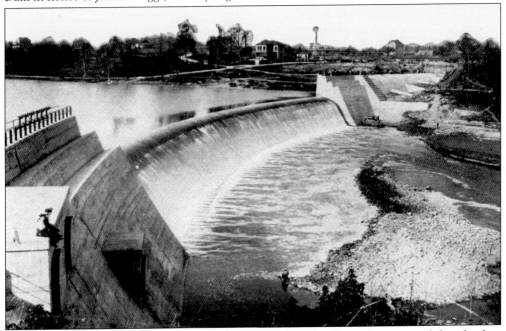

The Storage Dam was completed in 1905. During the 1913 flood, the rumor started that the dam had broken and people in downtown Columbus started running for high ground. Even if the dam had failed, the water would have spread out over such a large area that it would not have increased the water level more than a foot or so. Columbus native James Thurber memorialized this event in his short story, "The Day the Dam Broke."

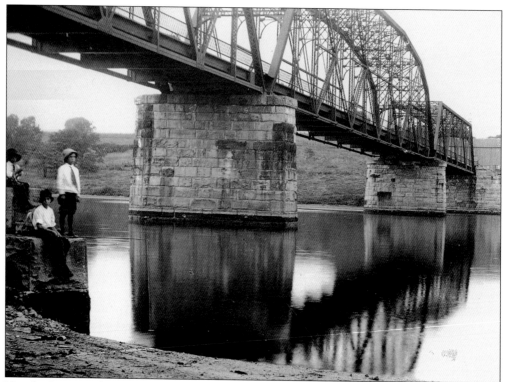

New bridges were built over the Scioto River in anticipation of the completion of the Storage Dam (now Griggs Dam) raising the water level in the river. This new bridge was built over the Scioto River at Fishinger Road in 1905. It served until replaced in 1986.

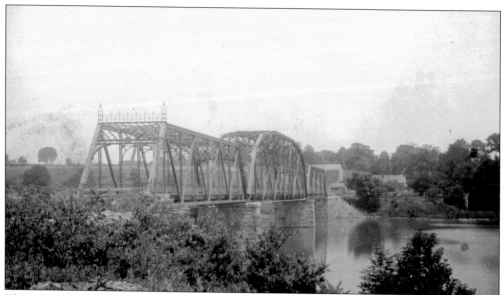

This photograph shows the Hayden Run Road Bridge over the Scioto River that was built in 1904. This bridge was replaced in 1984.

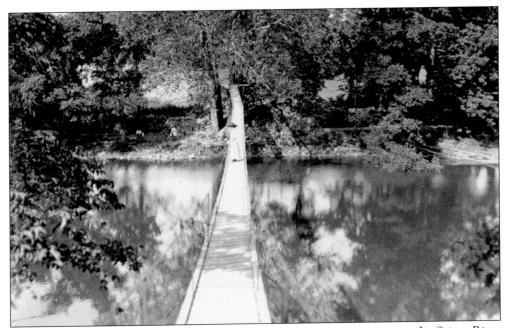

After the dam was completed, a swinging pedestrian bridge was strung across the Scioto River below the dam. Although it has not been documented how long this bridge remained in place, it is doubtful that it was there for more than a few years.

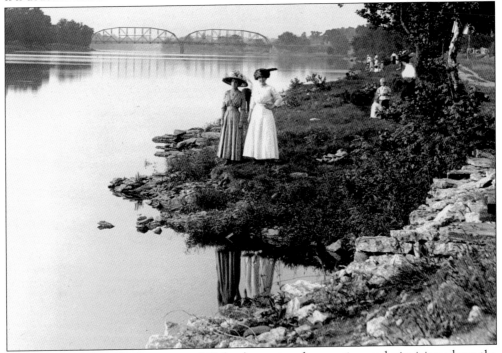

After the dam had filled, citizens of Columbus enjoyed recreation and picnicing along the shoreline. An interurban line was built from Columbus to the intersection of Fishinger Road and Riverside Drive (with the intension of reaching Dublin and Urbana) and people would ride the Dam Car out to the reservoir.

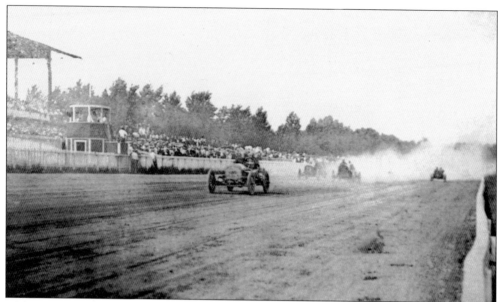

Although the Driving Park in southeast Columbus was established in 1892 as a one mile dirt track for trotting and pacing horse races, it also hosted bicycle races, motorcycle races, automobile races, and aviation and sporting events. This photograph shows an early automobile race. Driving Park remained in operation through 1925 when the land was then sold and subdivided for housing. Some of the world's best trotters and pacers, including the great Dan Patch, performed at the Driving Park track.

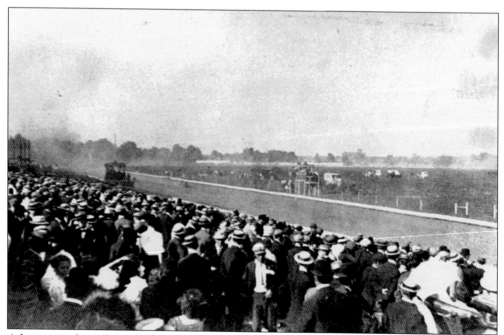

A large crowd watches an automobile race at Columbus's Driving Park. The world's first 24-hour automobile race was held on Driving Park's one-mile oval track on July 3 and 4, 1905.

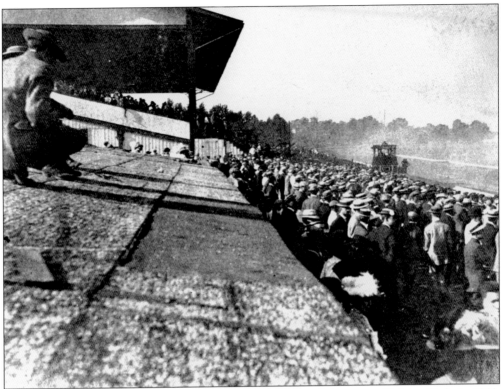

This photograph shows another view of the crowd at automobile races at Driving Park. In 1903, over 10,000 people came to Driving Park to watch Barney Oldfield set new world speed records.

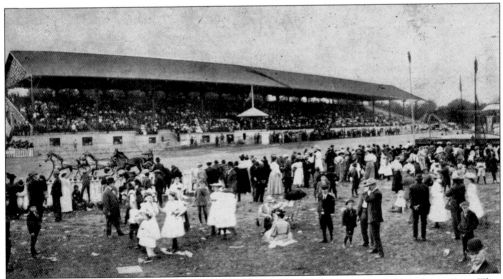

In addition to Driving Park, racing was also included as a feature of the Ohio State Fair. This picture shows trotter or pacers competing on the fairgrounds track.

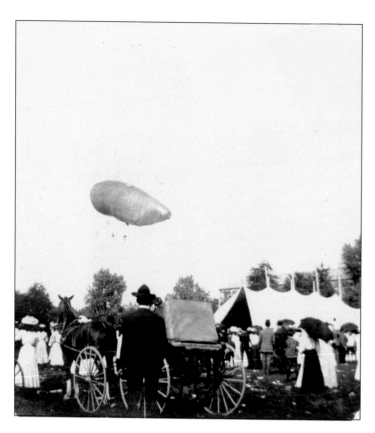

By 1905, Roy Knabenshue of Toledo had established himself as a professional balloonist. That year, the Ohio State Fair board contracted for him to make two flights each day at the five-day Ohio State Fair. Using a motorcycle engine to propel his balloon he could fly around and return to his launching spot, if the wind was not too strong.

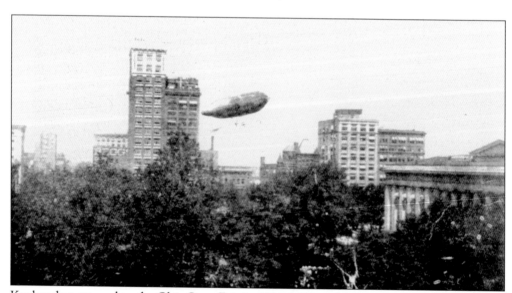

Knabenshue retuned to the Ohio State Fair in 1906, 1907, and 1908. During the 1906 fair, he flew his balloon downtown, landed on the state capital grounds, greeted Governor Harris and then flew back to the fairgrounds.

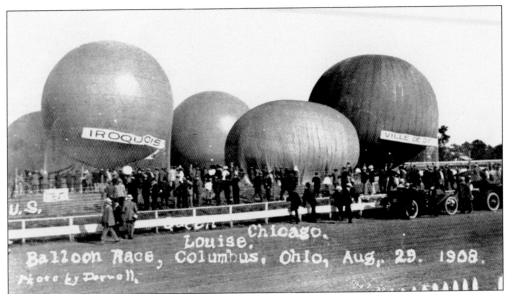

Columbus was the sight of an international balloon race in August 1908. Six large hydrogen-filled balloons were launched from the Driving Park. The winner of the race would be the balloonist who traveled farthest before his balloon landed (due to loss of hydrogen). The *Queen Louise* landed in Lake Erie 20 miles west of Buffalo and was declared the winner. The balloonist and the balloon were recovered.

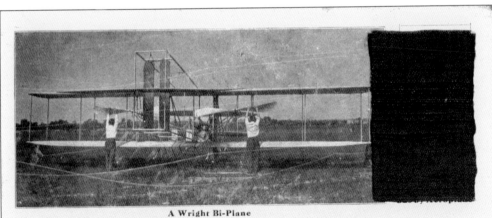

A Wright Bi-Plane

AVIATION DAY COLUMBUS, OHIO NOVEMBER 7, 1910

The Morehouse-Martens Co. made the first commercial use of the Aeroplane in the World's History of Aviation. A cargo of R. & T. Pluvette Salome Silk was shipped from Dayton to Columbus in a Wright Aeroplane and delivered to the Morehouse-Martens Co. at the Driving Park.

A Columbus retailer, Max Morehouse, hired the Wright brothers to have one of their pilots fly a bolt of silk from Dayton to Columbus. When Philip Parmalee landed at the Driving Park on November 7, 1910, he had completed the world's first air freight shipment. This postcard commemorates the flight and has a piece of the silk attached.

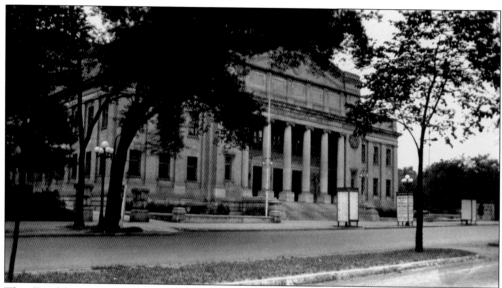

The Franklin County Memorial Hall at 280 East Broad Street was completed in 1906. Proposed many years earlier as a memorial to honor the Franklin County soldiers who fought on the Union side in the Civil War, financial issues delayed construction until after the Spanish-American War. Thus, when completed, it honored soldiers of both wars. It remained the primary county-owned meeting and entertainment facility until the Veterans Memorial Auditorium was erected on the west side of the Scioto River in 1955. Later on, it housed the Center of Science and Industry and now houses county offices.

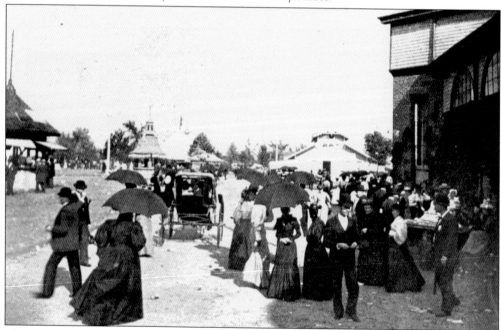

The Ohio State Fair has always attracted crowds, especially from rural Ohio. In the first decade of the 20th century, the fair only lasted five days, Monday through Friday of one week. The impact of the fair on Columbus can be realized when it is noted that state fair week was the busiest week of the year for touring the Ohio Penitentiary. Penitentiary tours were halted in the 1950s.

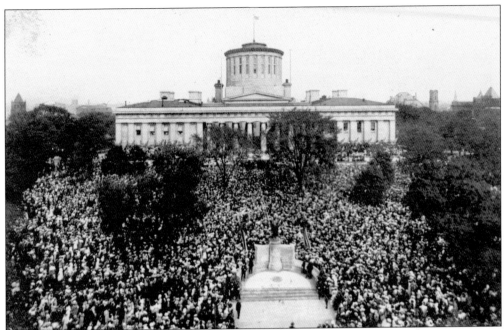

A massive crowd turned out on September 14, 1906, for the unveiling of the McKinley Monument in front of the state capital. Alice Roosevelt Longworth, the daughter of the Pres. Theodore Roosevelt, did the unveiling. The monument was located where Gov. William McKinley turned to wave to his invalid wife in their Neil House hotel suite as he walked across High Street to the governor's office each day.

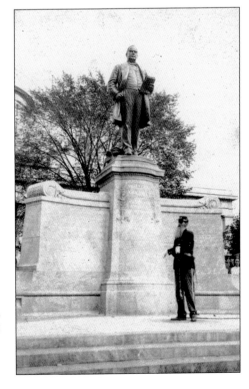

A Civil War veteran (in uniform) examines the McKinley Monument on the day of its unveiling. During the war, McKinley proved to be a valiant soldier and rose in rank from a private to a major. Possibly the veteran had been in a unit commanded by McKinley.

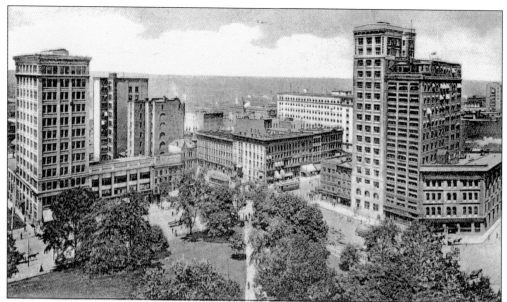

If one had looked northwest from the dome of the state house in 1906, one would have seen most of Columbus's skyscrapers of that day. These included the Harrison Building on the left and the Capital Trust Building (now 8 East Broad Street) and the Hayden Building (now 16 East Broad Street) on the right. The back sides of the Wheeler and Wyandot Buildings (both of which faced West Broad Street) are seen between the Harrison Building and the Deshler Block (the five-story building in the center). These skyscrapers were built between 1888 and 1906.

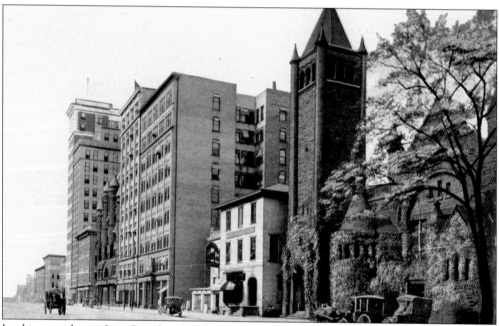

Looking northwest from Broad and Third Streets shows buildings across Broad Street from the state capital in 1906. The building to the left with the arch in front was the Board of Trade Building (erected 1889), to its right are the Outlook Building (erected 1901) and Spahr Building (erected 1897). The First Congregational Church is in the right foreground.

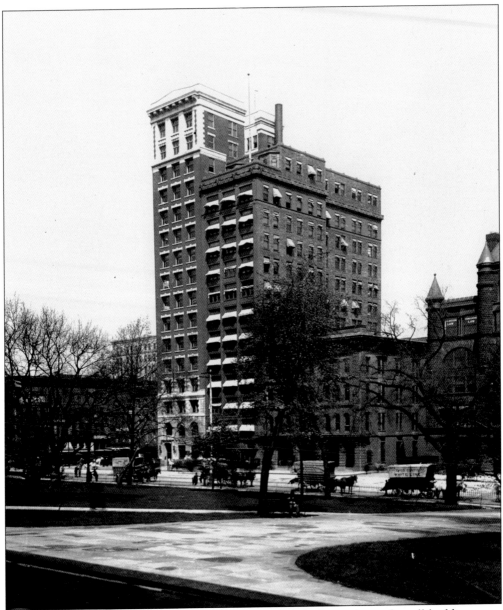

Another view of the northeast corner of Broad and High Street shows the tall buildings now referred to as the 8 East Broad Street Building (erected around 1906) and 16 East Broad Street Building (erected around 1904). In 2005, these early-20th-century buildings were in the process of being renovated.

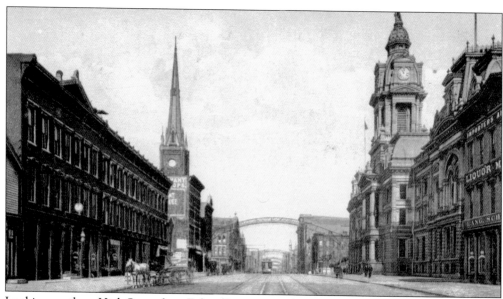

Looking north on High Street from Fulton Street around 1907, on the right are the Lang Schenck Company Liquors and the Franklin County Court House, the building with the large tower. The spire on the left is that of St. Paul's German Lutheran Church. The church was razed in 1917.

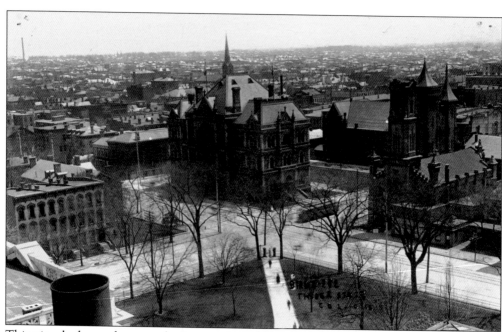

This view looks southeast to the intersection of State and Third Streets from the roof of the state house in 1907. In the center of the picture is the U.S. Post Office and Custom House, which was built in 1887 and enlarged between 1907 and 1912; it is now the Bricker and Eckler Building. The church in the right foreground was the former First Presbyterian Church; it was removed in 1911 and replaced by the Hartman Building and Theater.

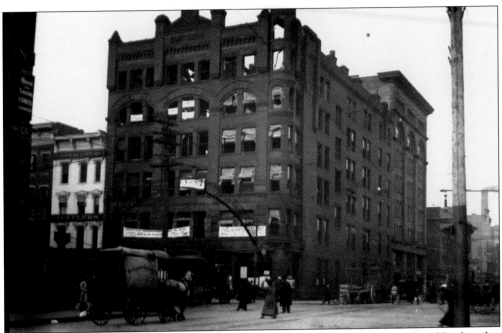

In 1907, the building at the northeast corner of High and Gay Streets was destroyed by fire; this photograph shows the building after the fire. The *Columbus Dispatch* newspaper, an occupant of the building, was forced to relocate until a new building was completed. By 1910, the building had been rebuilt and the *Columbus Dispatch* returned to this location which they occupied until 1925.

Dr. Samuel B. Hartman opened the Virginia Apartments in 1908 on the southeast corner of Gay and Third Streets. Apparently unsuccessful as an apartment building, he converted it into the Virginia Hotel in 1911. It remained open until 1961 when it was razed to clear the site for a larger hotel. The hotel that replaced it has been named the Columbus Plaza, Sheraton Columbus, Sheraton Downtown, Sheraton Columbus Plaza, Adams Mark Hotel, and, presently, the Renaissance.

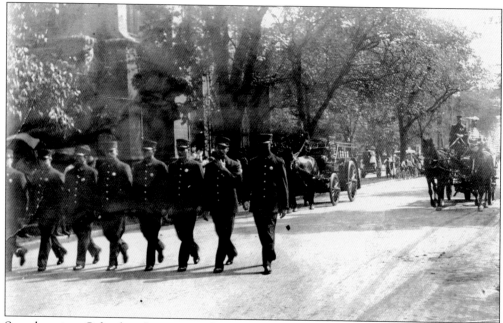

Seen here is a Columbus firemen parade on East Broad Street. The person of interest to the photographer was the driver of the ladder wagon (near the center). The photograph is undated but is likely to have been taken during the fire chief's convention in Columbus in 1908.

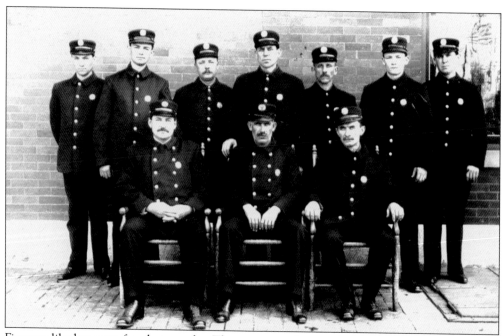

Firemen liked to pose for photographs. They are most frequently found in group photographs showing all the firemen of their particular station. This photograph shows the firemen of Engine House No. 5, at 121 Thurman Avenue, in 1908.

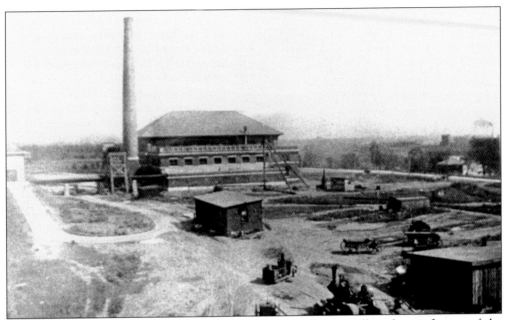

Columbus's first water works plant which pumped water from a well at the confluence of the Scioto and Olentangy Rivers was replaced by a new Scioto Water Purification Plant and Pumping Station on Dublin Road in 1908. The new facility was the first water plant to combine filtration and water softening and became known internationally as the Columbus Experiment.

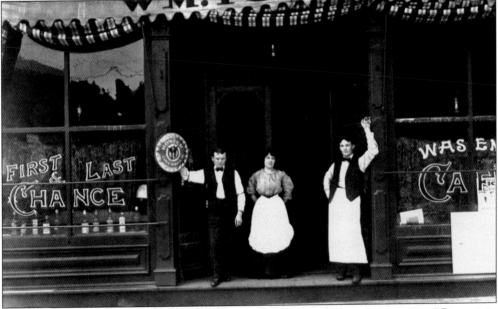

First and Last Chance Saloon was opened by an Italian immigrant, Salvatore "Papa" Presutti, in 1908. It was located on West Goodale Street in an area of Columbus that was called Flytown. In his autobiography, Presutti said that when he closed the saloon each night he would walk to the center of Goodale Street with his sack of money in one hand and a revolver in the other. After making a complete turn he would walk down the center of Goodale Street to where he lived. Later, Papa and Mama Presutti operated a well-known Italian restaurant on West Fifth Avenue.

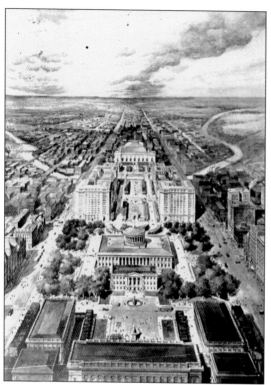

In 1908, a committee looked at Columbus with the idea of proposing a plan for future development. One of their proposals was for a mall way stretching west from the state house to the Scioto River, as shown here. Government buildings and museum would line the mall way. The city made no attempt to acquire the required land between High Street and the river. Private construction in the area (Majestic Theatre, 1914; Harrison Building, 1916; Neil House, 1925; and so on) ultimately made the land too costly to convert to public use.

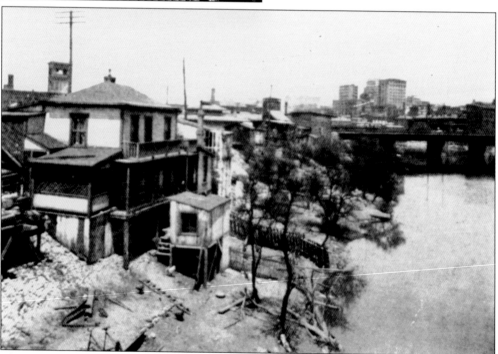

This picture from the 1908 report shows the conditions along the Scioto River in downtown Columbus. Although the proposed plan was not adopted in its entirely, the 1913 flood and the redevelopment that followed cleaned up this area.

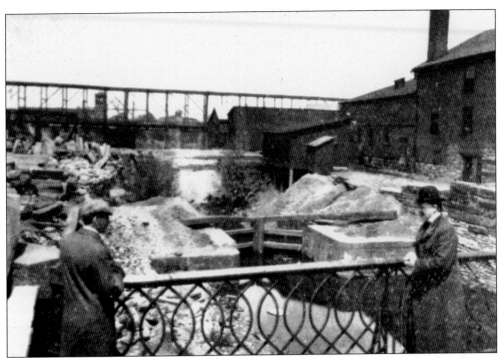

As part of the 1908 plan, it was proposed that the abandoned Feeder Canal be redeveloped into a place for public recreation. After the 1913 flood, the canal was filled in and the only reminder of it that can be found in downtown Columbus today is a historical marker in Bicentennial Park.

Another view shows the terrible conditions along the Scioto River in 1908. This photograph would have been taken from where the Ohio Judicial Building (formerly the Ohio Departments Building) now sits. The rotunda of the state house can be seen in the left of the picture.

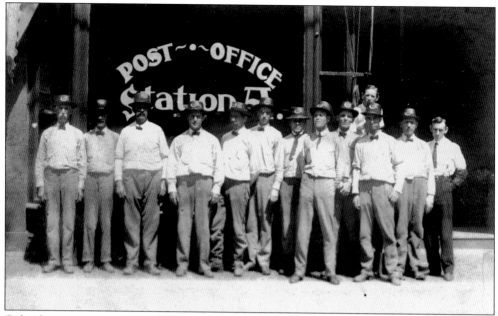

Columbus postmen are posed in front of the Postman of Columbus Station for this 1908 photograph. The station was located at 1222 North High Street and was the northern most station at that time. The postmen all wore white shirts, most choosing to wear bow ties, although a few choose longer ties.

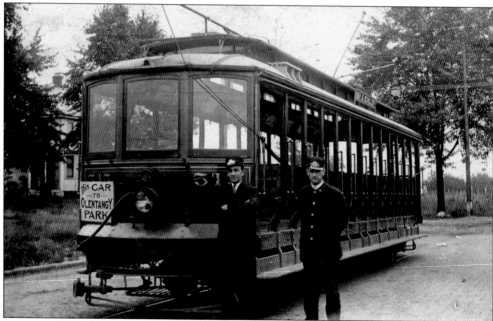

Numerous photographs are found of motormen and conductors posing beside their streetcars. These photographs generally date from the 1910 period. These men are posed beside their summer, or open, streetcar in 1908. Open-sided streetcars were used in the summer in the days before air conditioning, but were abandoned in the 1920s, probably for safety reasons.

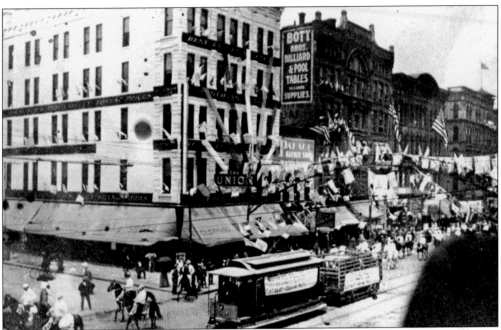

In 1906, the Columbus police held a public barbeque at Driving Park. To advertise the barbeque, policemen toured the downtown area on a streetcar towing an open car with two steers. Signs on the streetcar and cattle car read, "Notified police, they say they are going to barbeque and eat us at the Driving Park, June 6th."

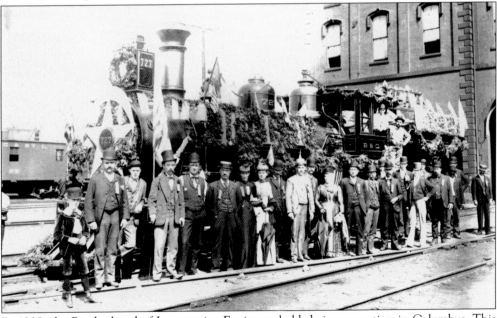

In 1908, the Brotherhood of Locomotive Engineers held their convention in Columbus. This photograph shows some of the conventioneers and a locomotive decorated for the convention. The Baltimre and Ohio Engine 727 was a 4-4-0 locomotive built at the company's Mount Clair shop between 1873 and 1875. One evening during the convention the engineers toured Columbus on 44 streetcars.

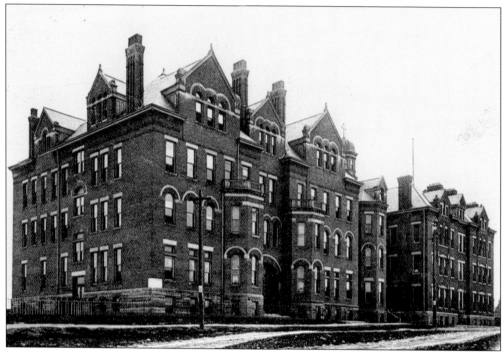

By 1908, Mount Carmel Hospital had added a school of nursing, a chapel, and a six-story wing to become one of the largest hospitals in central Ohio. Through the years, Mount Carmel has continued to update its buildings, removing older structures and replacing them with state-of-the-art facilities.

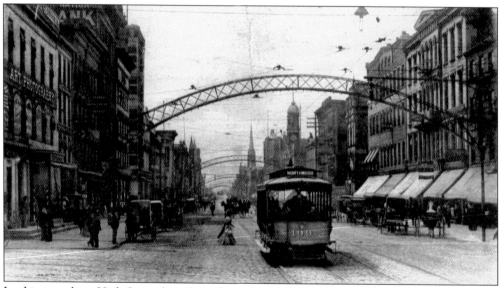

Looking south on High Street from State Street around 1908, the tunnel formed by the arches is readily apparent in this picture. This picture also shows a safety issue with the streetcars because riders had to step nearly to the center of the street to catch a streetcar, and they were dropped off near the center of the street. In earlier days, when traffic was light and slow, this may not have been a problem. Today it probably would be unacceptable.

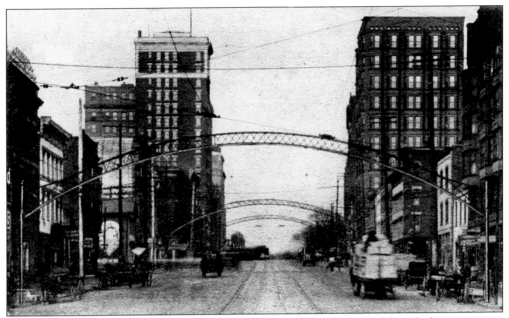

Columbus had so many arches that it proclaimed itself the Arch City. Although there are many views of arches on High Street, there are few views showing the arches that were erected on other streets. This c. 1910 view shows the arches on West Broad Street between the Scioto River and High Street.

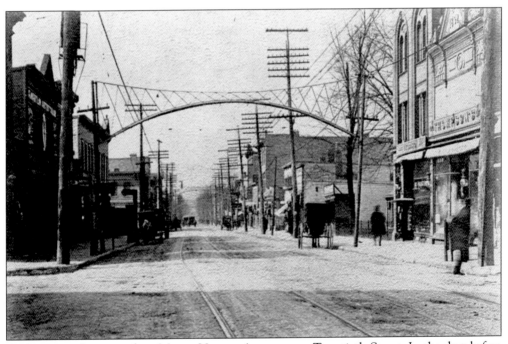

Arches were also erected on Mount Vernon Avenue near Twentieth Street. In the days before the freeway cut off Mount Vernon Avenue from downtown Columbus, the Mount Vernon area was a bustling business district with a mixture of ethnic groups represented.

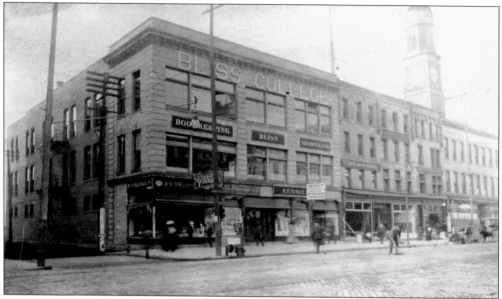

Bliss College provided business education for Columbus students from 1899 until it closed in 1993. During its life, Bliss College operated out of several locations. This photograph shows their facility at 187 South High Street (at Walnut Street) in 1909. It also shows the Spalding Athletic and Gymnasium Supplies store at 191 South High Street.

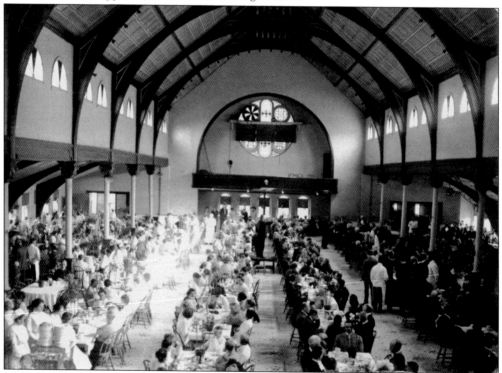

This photograph of inmates dining at the State Hospital, or others like it, primarily appeared on postcards. Why anyone at that time would have been interested in such a picture is not known. However, now that the facility has been razed, they have historical value.

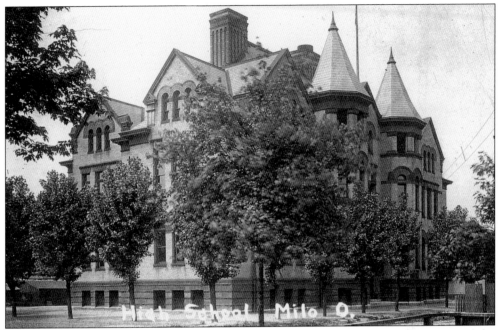

The Milo High School was built at 617 East Third Avenue in 1894. It became part of the Columbus Public School system after Milo and Grogan were annexed to Columbus in 1910. In recent years, the building has housed a flea market and art activities.

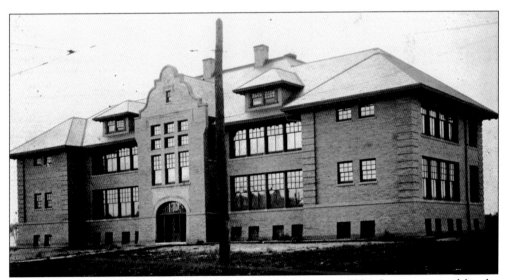

The Grogan School was built at 880 East Eleventh Avenue in 1904. It was acquired by the Columbus Board of Education when Milo and Grogan were annexed to Columbus in 1910. The Columbus school board renamed it the Eleventh Avenue Elementary School. After the school was closed, it was damaged by a fire (1994) and then razed.

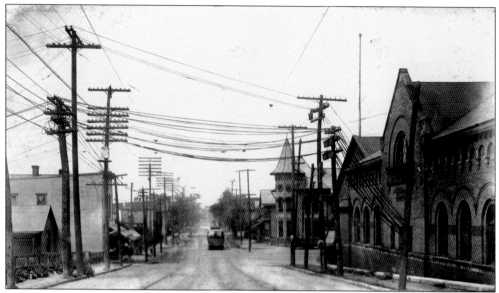

This 1910 view looks north on Cleveland Avenue from the Norfolk and Western Railroad viaduct. The first building on the right is a Columbus Railway, Power and Light Company power plant. Next is the Columbus Railway, Power and Light Company streetcar barn. Across Reynolds Avenue is a Columbus Railway, Power and Light Company office.

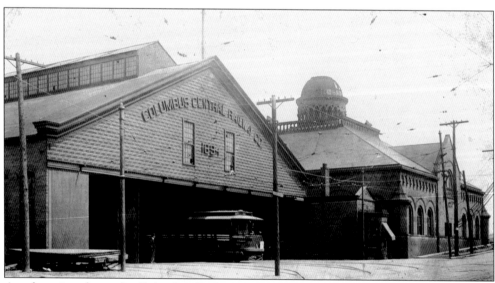

Another view shows the Columbus Railway, Power and Light Company car barn and power plant. These facilities were originally built for the Columbus Central Railway Company in 1894, but were acquired by the Columbus Railway, Power and Light Company in a merger.

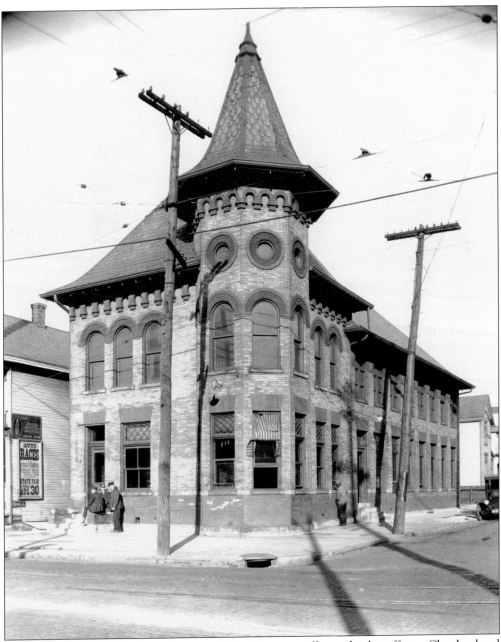

This former Columbus Railway, Power and Light Company office and ticket office at Cleveland and Reynolds Avenues is an interesting looking building. Unfortunately, the Milo area in which it is located is an area that is run down and, thus, the building is not being put to use. It is boarded up and awaits redevelopment of the area.

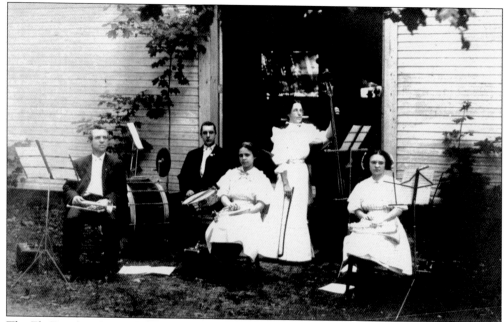

The Ely Family, of 155 East Eleventh Avenue, offered music in 1910. In the days before records, tapes and cds, if you wanted music you had to hire live musicians. This provided opportunities for young people to develop musical skills and for adults to either earn a living (if they were good enough) or to earn some extra money. This combination offered a bass player, a three person brass section, and a percussionist.

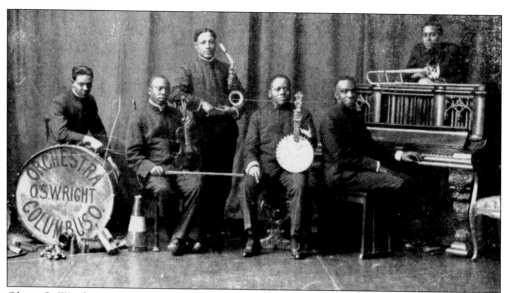

Oliver S. Wright and his orchestra were another Columbus group. Small groups such as these offered black youngsters an opportunity to develop musical skills and earn some money. Many noted black musicians of the 1930s and 1940s got their start in groups such as these. A Columbus barber, Charlie Parker is reported to have had about 40 small musical groups for which he would arrange playing dates.

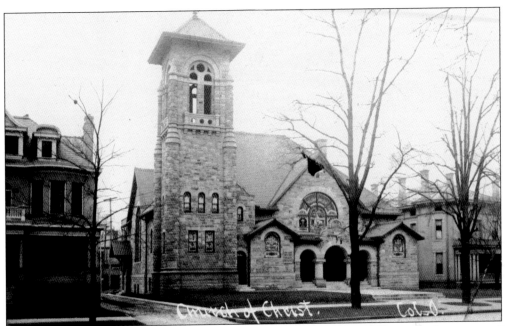

The Broad Street Church of Christ was located at 1049 East Broad Street at the corner of Twenty-first Street. The church was organized as Central Christian Church in 1870. It relocated to this new facility in 1907 and became Broad Street Christian Church. It is Columbus's oldest Christian Church. For many years the messages of its pastor, Rev. Floyd Faust, were broadcast on local radio.

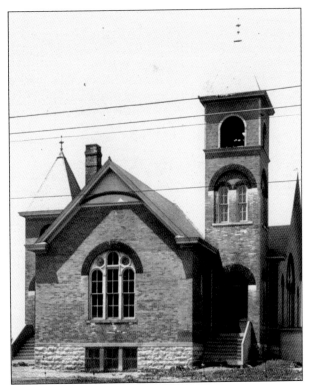

This 1908 photograph is of the Union Methodist Episcopal Church in Briggsdale. Briggsdale has since been annexed to Columbus. The church became the Briggsdale United Methodist Church in the late 1960s. After struggling for some years the congregation merged with the Salem Heights United Methodist Church and is now renewing its efforts to serve the community as New Horizons United Methodist Church.

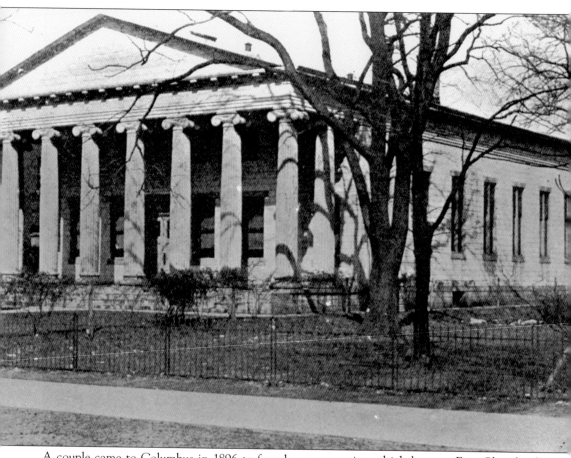

A couple came to Columbus in 1896 to found a congregation which became First Church of Christ Scientist. The congregation had its first service in this building at 336 East Broad Street at Grant Avenue on Thanksgiving Day, 1903. In 1915, they moved into a new facility as 457 East Broad Street and are still located there.

Seven

BUSINESS AND INDUSTRY IN THE NEW CENTURY (1900–1910)

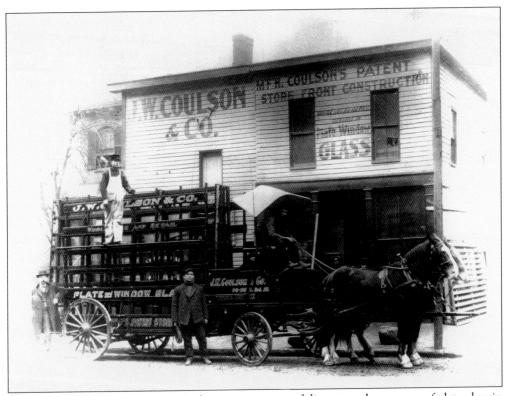

The J. W. Coulson and Company is shown preparing to deliver some large panes of plate glass in this 1906 photograph. Coulson seems to have had several interests as he had earlier been a painter, at the time of this photograph he was in the wholesale and retail plate glass business, and he had patented a store front construction, as advertised on his building and on the delivery wagon. The business was located at 96–98 North Third Street when this photograph was taken.

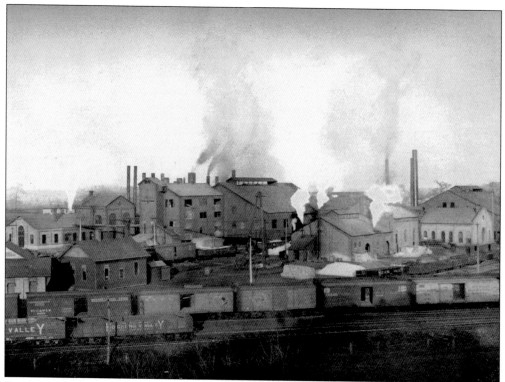

For those of us living in the early 21st century, when government, banking, insurance, education, and research are the primary Columbus occupations, scenes of heavy industry and manufacturing in Columbus seem strange. However, as seen by the industries shown in this book, Columbus has a strong industrial history. This photograph shows the National Steel Company works in Columbus; this company was in business on South High Street at the railroad from about 1900 to 1903.

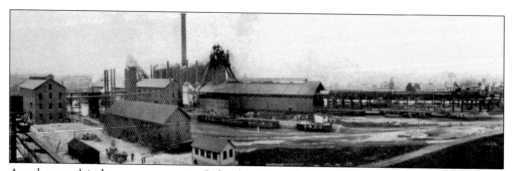

Another steel industry company in Columbus (in addition to the Carnegie Steel Company mentioned earlier) was the Columbus Iron and Steel Company. They erected a blast furnace in 1905 at their facility on Parsons Avenue at the railroad viaduct. In 1917, the owners sold out to Armco and in 1928 the blast furnace was moved to Hamilton, Ohio, where Armco had other facilities.

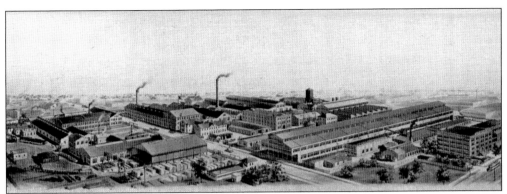

In 1876, the Lechner Mining Machine Company was formed in Columbus to manufacture coal mining machinery. In 1888, this company became the Jeffrey Manufacturing Company, and by the early 1900s, had become one of the leaders in the production of mining machinery. Jeffrey remained a Columbus business until 1974 when it was acquired by Dressler Industries. After that the manufacturing was moved out of Columbus. The North Fourth Street area formerly occupied by the Jeffrey plant is now being redeveloped.

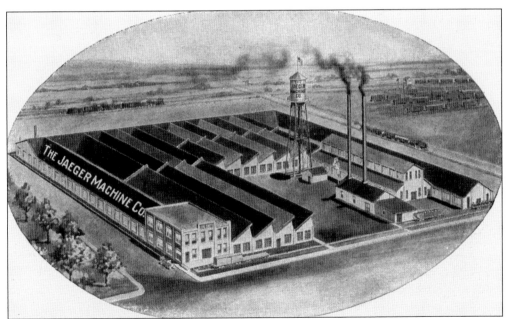

Gebhard Jaeger came to Columbus in 1902 and designed the first concrete mixing machine in 1905. In 1906, he established the Jaeger Machine Company, first at 217 West Rich Street and later at 518 Dublin Avenue (now Nationwide Boulevard). The firm prospered and became the world's largest manufacturer of concrete mixer trucks. After nearly 90 years of manufacturing concrete mixers, the company closed in 1992.

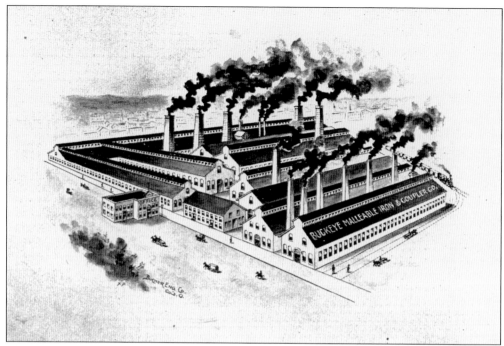

The Buckeye Malleable Iron Company was incorporated in 1886. It was not successful until 1893 when Congress required railroads to adopt automatic couplers. In 1902, the company relocated to this facility on Parsons Avenue in the Steelton area and changed their name to the Buckeye Steel Casting Company. They continued in business until closing in 2002. It subsequently was sold and reopened as Columbus Steel Castings in 2003. From 1908 to 1928, Samuel P. Bush (George Herbert Walker Bush's grandfather) was president of the company.

The Kinnear door company was a leading manufacturer of metal overhead doors. The plant was located a short distance northwest of the intersection of Cleveland and Fifth Avenues, in an area known as Milo. Milo was a working class neighborhood mostly populated with Italians at that time. This photograph shows the Kinnear plant shortly before the Milo and Grogan areas were annexed to Columbus in 1910.

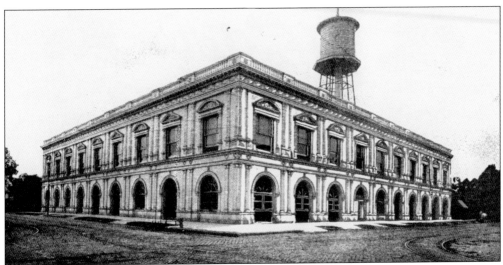

Dr. Samuel B. Hartman's greatest fame related to his tonic, Peruna, that he claimed was "the purest, most prompt, and efficient medicine known to man." After relocating to Columbus in 1883, he built production and treatment facilities here. This building was completed in 1906 at the southeast corner of Third and Rich Streets to serve as the administration and manufacturing headquarters. In advertisements it was said that Peruna "contains no whiskey." Sales declined after the Pure Food and Drug Act of 1906 required disclosing that Peruna was about 30 percent alcohol. The building was razed in 1973.

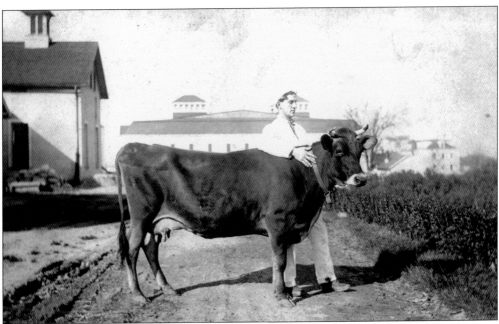

The Hartman Farm was a 3,500 acre farm south of Columbus acquired by Dr. Samuel B. Hartman by investing the fortune he made from selling his Peruna tonic. One of the farm operations was a large dairy. This photograph shows one of their prize cows. Hartman Farm milk bottles are sought after by bottle collectors. Among other operations of the Hartman Farm were orchards, ducks, and raising prize horses.

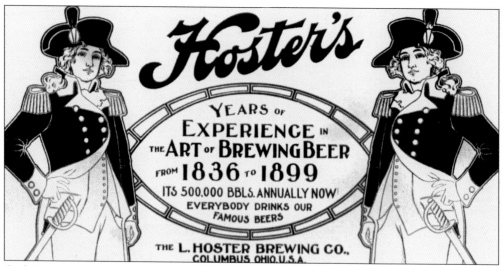

Carl Hoster founded a brewery in Columbus in 1836. It was the major brewery among eight breweries that operated in Columbus in pre-Prohibition days. However, it disappeared with Prohibition. The Hoster name has been revived for a micro-brewery, but it is not related to the earlier brewery.

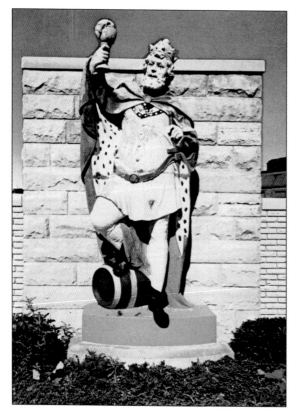

After the August Wagner Brewery plant was razed, the King Gambrinus statue that had been a decoration on the front of the plant since 1905 was mounted on a pedestal at the intersection of Front and Sycamore Streets. It was later moved to the front of Brewer's Yard Park.

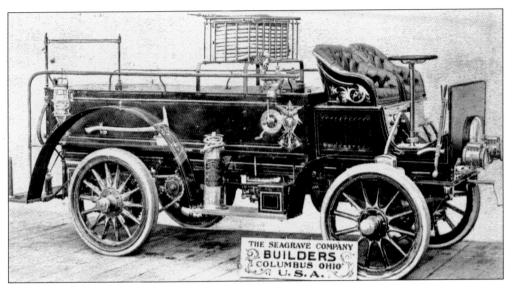

In 1907, Seagrave began manufacturing engine-driven fire vehicles. This builder's photograph is of one of their first motorized products, a chemical and hose wagon. To demonstrate the capability of their vehicles, the Seagrave Company had one of these vehicles driven from Chillicothe to Columbus (55 miles), a distance well beyond what any fire department would be expected to cover.

Seagrave then began to adapt their vehicles to pull older fire equipment. This picture shows a hose wagon pulling a steam pumper engine. This permitted some fire departments to convert to motorized equipment without having to write off their older equipment. However, with this combination a fire was still needed in the boiler to pump water. Fire vehicles with engine driven pumps gradually replaced the steam pumps.

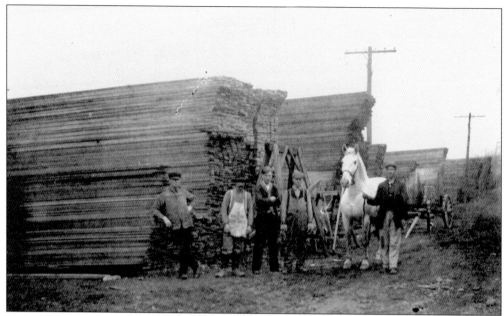

In the first decade of the 20th century, before fork lift trucks and other mechanical devices were available, lumber had to be handled by hand and delivered by horse-drawn wagons. Also, lumberyards would almost certainly be located on railroad sidings to simplify receiving materials. This scene of an unknown Columbus lumberyard shows some of the employees taking a break.

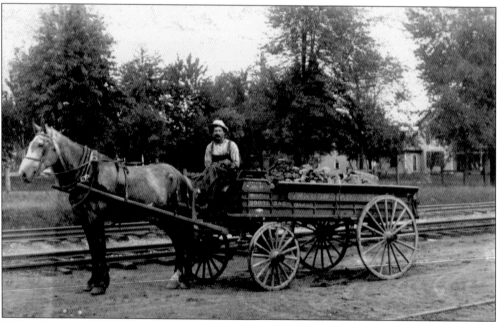

Although natural and manufactured gases were available in some parts of Columbus and were used for lighting, most residences and businesses were heated by coal during the first decades of the 20th century. This meant that coal had to be delivered to nearly every residence and business. This photograph shows a wagon load of coal in route to a consumer. Like lumberyards, coal yards were located on railroad sidings to enable delivery by train.

F. and R. Lazarus Company moved into this new store that they had built on the northwest corner of Town and High Streets in 1909. The building was later enlarged and additional building constructed. Lazarus grew to become the largest and most important department store in Columbus. Although outlying regional shopping centers eventually took business away from the downtown stores and such stores were closing in many cities, Lazarus was a holdout until finally closing their downtown store in 2004.

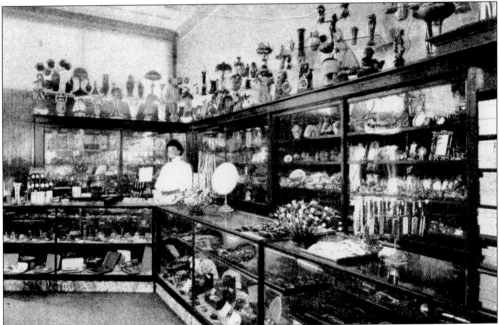

William G. Dunn founded a dry goods and notions store in Columbus in 1869. When he formed a partnership with Daniel H. Taft in 1889, the store became the Dunn Taft Company, and was located at 84–86 North High Street. In 1930, the company moved to 106–110 North High Street before going out of business in 1941. This picture shows their bric-a-brac department around 1906.

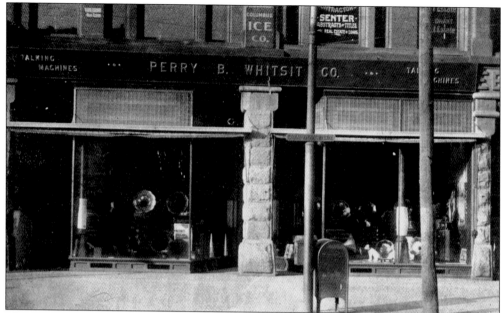

The Perry B. Whitsit Company was founded in Columbus in 1909. Located at 213 South High Street, among the items they sold were Edison and Victor Talking Machines. Phonograph records had only become practical about 1906, but were gaining popularity. Therefore, the Whitsit store was state-of-the-art for its time. Because electricity was not universally available, record players of that time were powered by hand cranking. The company continued in business until 1952.

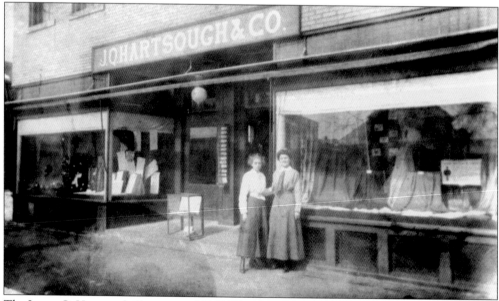

The James Q. Hartsough Company, of 1240 West Broad Street in the Franklinton area, is shown in this 1910 photograph. It appears that the store sold paper goods.

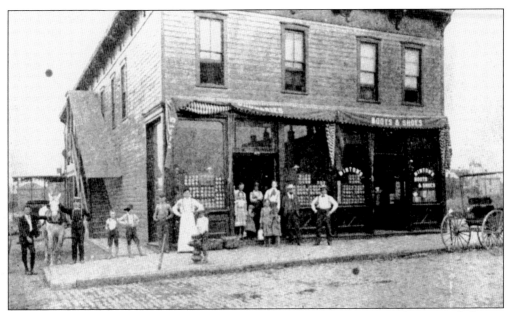

This 1901 photograph is of the Daniel J. Minton Grocery store at 479 North Twentieth Street. The business was founded in 1896 and ceased business in 1910. Minton lived only a few doors away, at 448 North Twentieth Street. He also operated a coal yard at Krause Avenue and Railroad Street and is known as having platted a small subdivision that included his residence.

This 1909 photograph shows the business of Michael Voit who was a shoemaker. From year to year, his business moved around the neighborhood in which he lived, suggesting that he rented shop space rather than owned it. This photograph was taken when his business was located at 329 West Third Avenue. Undoubtedly, Voit is the man standing in the doorway. Unfortunately, most old photographs do not provide sufficient information to identify the activity or even the location.

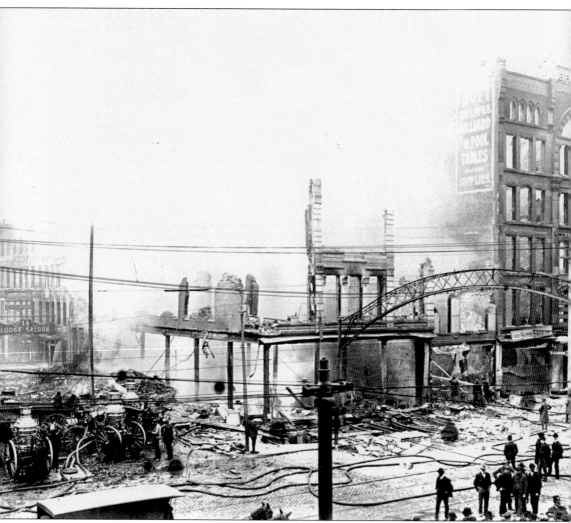

In April 1903, a fire that started in the Bott Brothers café destroyed the Brunson Building and the four-story Union store on the northwest corner of Long and High Streets. One fireman, Daniel S. Lewis, was killed fighting the fire. The Union store was rebuilt at four stories, but was increased to six stories in 1909. The Union store remained in that building until 1968 when they moved to South High Street into a space formerly occupied by the Morehouse-Fashion.

Eight

OLENTANGY PARK

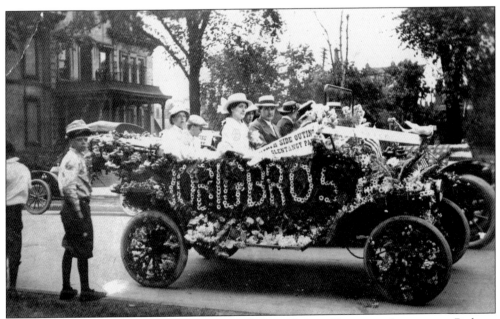

From 1896 to 1937, Columbus citizens enjoyed the 100-acre Olentangy Amusement Park on North High Street. The annual North Side Outing at Olentangy Park was one of the biggest events of the summer at the park, and was preceded by a parade to the park. This photograph shows an automobile (probably a Ford Model T) decorated as a float on its way to the park.

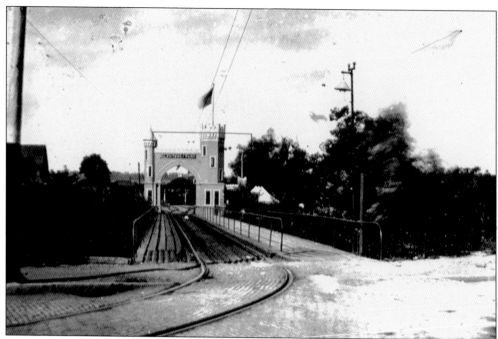

Olentangy Park was a trolley park in that it was located at the end of the streetcar line and was opened to encourage streetcar traffic during off hours. It was located on North High Street at Arcadia Avenue, across High Street from a streetcar barn. This photograph shows the streetcar entrance in the early years; the entrance was later enlarged to accommodate two tracks so streetcars could enter, make a loop, and exit.

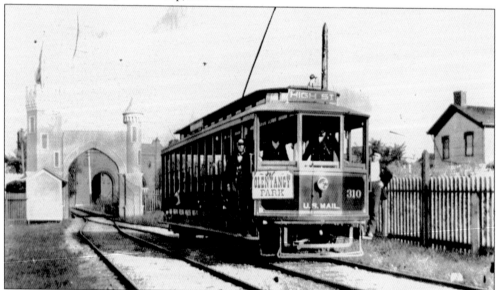

This photograph shows a park-bound streetcar that has just entered the gate. Some things that might be noticed in this picture are that it is a summer car (open sides), it has an advertisement for Olentangy Park on the front and that the streetcar has a label "U.S. Mail" on its front. At least some Columbus streetcars were equipped to receive outgoing mail. No envelope with a Columbus streetcar cancellation is known to exist.

A streetcar that has just unloaded passengers at the Olentangy Park station is seen here. While the passengers have proceeded to the gate, the motorman and conductor have taken time to pose in front of their streetcar.

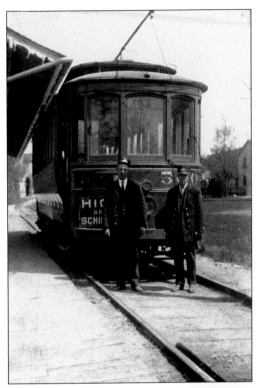

There was also a walk-in gate for patrons that lived in the area. The sign makes it clear that Olentangy Park is "private grounds for use of orderly reputable people; others not wanted or permitted on the grounds." Unlike the Olentangy Villa, which had preceded Olentangy Park at this site, gambling and alcohol were not permitted.

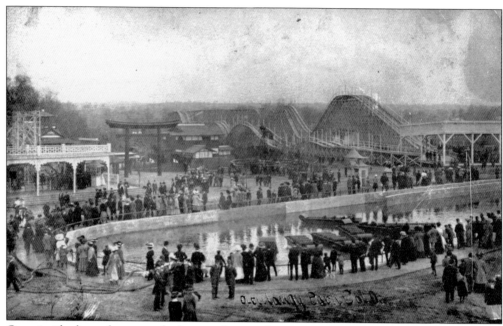

Once inside the park, patrons had many choices of entertainment. These included several roller coasters, the Shoot-the-Chutes and other rides, the Fair Japan, dancing, vaudeville, the park zoo, and floral displays.

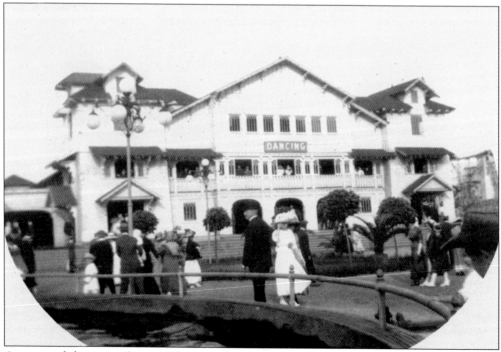

A new steel dance pavilion at Olentangy Park was erected in 1908. This pavilion was said to be the first in Columbus that had a rotating ball with a multitude of mirrored surfaces to reflect light spots all over the dance floor. Dancing was a popular low cost attraction during the 1920s and 1930s when many people had limited incomes.

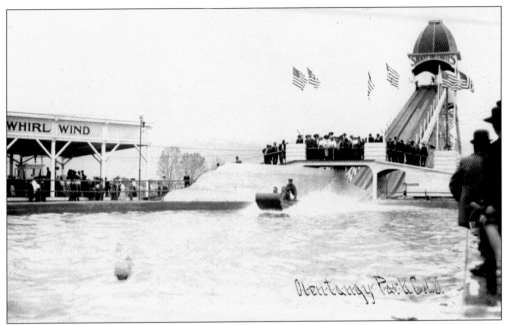

One of the rides at Olentangy Park was the Shoot-the-Chutes. A boat was pulled up the incline with a chain, like the first incline of roller coasters. At the top the boat was turned around and pushed to start it back down the incline on a wetted and slippery surface. When the boat hit the pool of water it caused a spray, much like the log rides of later years. Considering that park visitors dressed up at that time, it would not have been desirable for the riders to get wet.

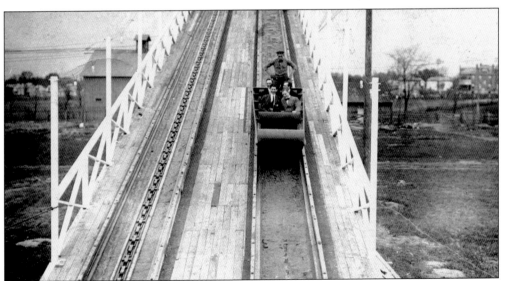

Park goers remember a special feature of the Shoot-the-Chutes ride at Olentangy Park was that the park employee accompanying each boat would stand up all the way down the ride.

The Olentangy Park brought the Fair Japan exhibit from St. Louis following the close of the 1904 Louisiana Purchase Exhibition. Forty Japanese workers were brought to Columbus to erect the exhibit and about half stayed to operate the exhibit and entertain park visitors. Japanese foods were served in a restaurant and native ceremonies and mock sword fights were conducted as entertainment. This picture shows the Banzai Bridge in the Fair Japan exhibit.

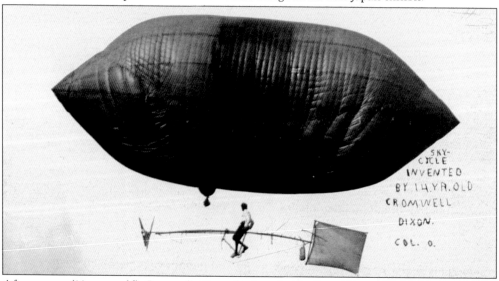

After young (14 years old) Cromwell Dixon had made his first flight in his Sky-cycle, he was employed to make regular flights at Olentangy Park. The Sky-cycle had a hydrogen filled bag with a structure suspended beneath it. The structure held young Dixon, a propeller, his bicycle-petal rig for turning the propeller, and a rudder to control direction. After only a few flights, he and the park had a disagreement over compensation and he took his Sky-cycle elsewhere.

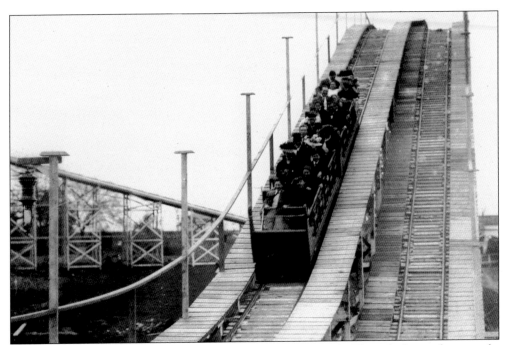

The Racer was one of the larger roller coasters at Olentangy Park. This ride featured two tracks and both cars were usually started at the same time. Thus, they raced over the inclines and dips. It is not known why only one car shows in this photograph; possibly it was so the photographer would not be at risk of being hit by the other car while taking the picture.

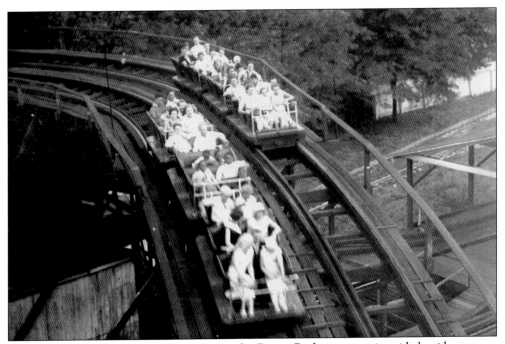

Two carloads of riders seem to be enjoying the Racer. Both cars running side-by-side gave an extra thrill.

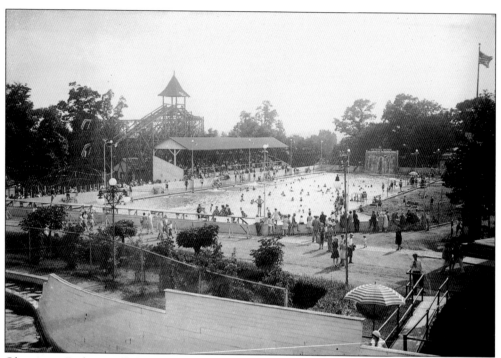

Olentangy Park installed a large swimming pool that included a waterfall at one end, a grandstand, and beach sand that had been brought in from Lake Erie. Swim suits were rented to patrons so that they could change at the park and not have to wear their swimsuit all day. Swimming and dancing are the attractions most often mention by former park goers.

This photograph of swimmers probably dates from the 1930s as more conservative bathing suites were worn in earlier periods.

Olentangy Park was equipped with a photographer who would take pictures in front on scenic backdrops. The most common photographs were those with the person or persons posed in front of a backdrop showing the entrance to the park, as if to say, see, I was there. These pictures provided patrons with a souvenir of their day at the park.

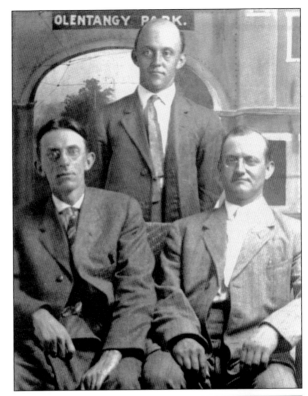

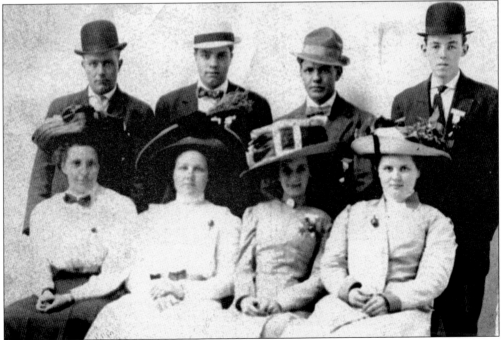

Although it seems strange to us today, in the first two decades of park operation, park visitors dressed up; men wearing ties and jackets and women wearing long dresses and hats. It has been observed that few photographs of early park patrons show smiles.

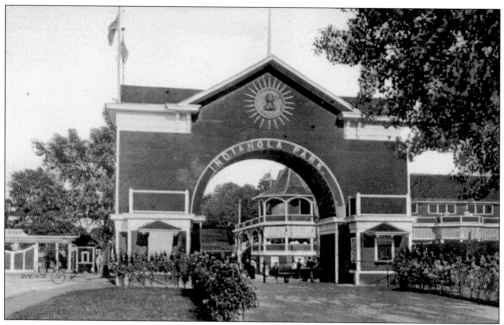

Another amusement park in Columbus was Indianola Park. Although it was much smaller than Olentangy Park, it offered many of the same features such as swimming, dancing, and rides. Rides included a roller coaster and a Shoot-the-Chutes. However, it did not have features to compete with the Olentangy Park's Fair Japan and zoo.

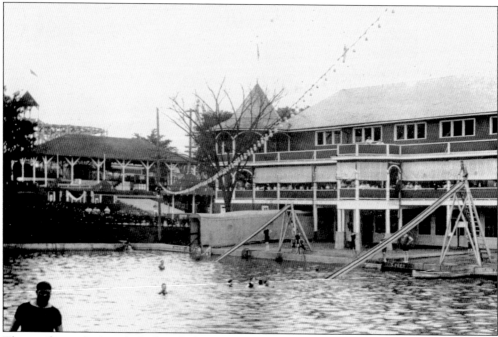

The pavilion at Indianola Park included a dance hall on the upper level and changing rooms on the lower level. The enclosed walkway from the pool to the bathhouse does not appear in most pictures of the park. Presumably this photograph was taken during a period of cool weather with the walkway shielding swimmers from cool breezes.